Remembering Nashville

Jan Duke

TURNER
PUBLISHING COMPANY

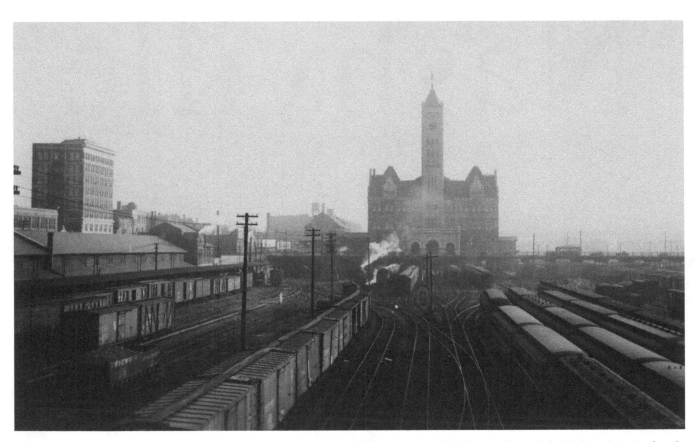

Union Station and the railroad yard, circa 1930. The eight-story building on the left held the offices of the N.C. & St.L. Railroad.

Remembering
Nashville

Turner Publishing Company
4507 Charlotte Avenue • Suite 100
Nashville, Tennessee 37209
(615) 255-2665

Remembering Nashville

www.turnerpublishing.com

Library of Congress Control Number: 2010902275

ISBN: 978-1-59652-601-3

Printed in the United States of America

ISBN: 978-1-68336-858-8 (pbk)

10 11 12 13 14 15 16—0 9 8 7 6 5 4 3 2 1

CONTENTS

ACKNOWLEDGMENTS.. VII

PREFACE ... VIII

EVE OF THE CIVIL WAR TO THE CENTENNIAL
(1850s–1899)... 1

AT THE TURN OF THE CENTURY
(1900–1916) .. 55

THE FIRST WORLD WAR AND A GROWING METROPOLIS
(1917–1939) .. 81

EMERGENCE OF THE MODERN CITY
(1940–1979) ... 115

NOTES ON THE PHOTOGRAPHS 131

This photograph captures shadows of the Parthenon columns.

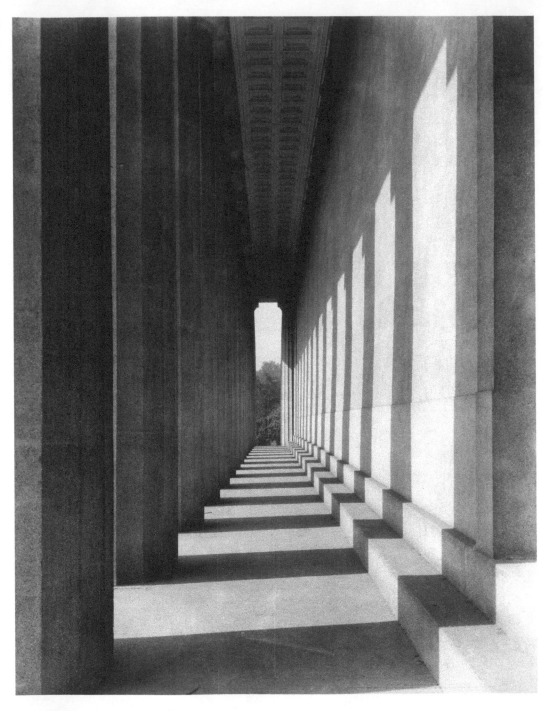

Acknowledgments

This volume, *Remembering Nashville,* is the result of the cooperation and efforts of many individuals, organizations, and corporations. It is with great thanks that we acknowledge the valuable contribution of the following for their generous support:

AmSouth Bank	Bass, Berry & Sims
First Tennessee	FirstBank
KraftCPAs PLLC	LifeWay
LBMC	The Nashville Room—Nashville Public Library
Pinnacle Financial Partners	Southern Baptist Historical Library and Archives
Tennessee Historical Society	Tennessee State Library and Archives
US Bank	Vanderbilt University Library and University Archives

We would also like to express our gratitude to Phil Duke for providing research, assisting the writer, and contributing in all ways possible.

Finally, we would like to thank the following individuals for their valuable contribution and assistance in making this work possible:

Steven Gateley, Research Service Librarian, LifeWay
Susan Gordon, Archivist, Tennessee State Library and Archives
Lyle Lankford, Public Affairs Office, Vanderbilt University
Beth Odle, Special Collections Division, Nashville Public Library
Henry Shipman, Photographic Assistant, Vanderbilt University Library
Bill Sumners, Director, Southern Baptist Historical Library and Archives
Ridley Wills II, Historian

PREFACE

Nashville has thousands of historic photographs that reside in archives, both locally and nationally. This book began with the observation that, while those photographs are of great interest to many, they are not easily accessible. During a time when Nashville is looking ahead and evaluating its future course, many people are asking, How do we treat the past? These decisions affect every aspect of the city—architecture, public spaces, commerce, and infrastructure—and these, in turn, affect the way that people live their lives. This book seeks to provide easy access to a valuable, objective look into the history of Nashville.

The power of photographs is that they are less subjective than words in their treatment of history. Although the photographer can make subjective decisions regarding subject matter and how to capture and present it, photographs seldom interpret the past to the extent textual histories can. For this reason, photography is uniquely positioned to offer an original, untainted look at the past, allowing the viewer to learn for himself what the world was like a century or more ago.

This project represents countless hours of review and research. The researchers and writer have reviewed many hundreds of photographs in numerous archives. We greatly appreciate the generous assistance of the individuals and organizations listed in the acknowledgments of this work, without whom this project could not have been completed.

The goal in publishing this work is to provide broader access to this set of extraordinary photographs, as well as to inspire, provide perspective, and evoke insight that might assist citizens as they work to plan the city's future. In addition, the book seeks to preserve the past with adequate respect and reverence.

With the exception of touching up imperfections that have accrued with the passage of time and cropping where necessary, no changes have been made. The focus and clarity of many images is limited by the technology and the ability of the photographer at the time they were taken.

The work is divided into eras. Beginning with some of the earliest known photographs of Nashville, the first section records photographs from before the Civil War through the Centennial. The second section

spans the beginning of the twentieth century to World War I. Section Three moves from World War I to the eve of World War II. And finally, Section Four covers the World War II era to the late 1970s.

In each of these sections, we have made an effort to capture various aspects of life through our selection of photographs. People, commerce, transportation, infrastructure, religious institutions, and educational institutions have been included to provide a broad perspective.

We encourage readers to reflect as they walk in front of the State Capitol, along the riverfront, or through Centennial Park. Cannons were once positioned on the Capitol steps, steamboats once lined the banks of the Cumberland, and many buildings, long since demolished, surrounded the Parthenon in Centennial Park. It is the publisher's hope that in utilizing this work, longtime residents will learn something new and that new residents will gain a perspective on where Nashville has been, so that each can contribute to its future.

—*Todd Bottorff, Publisher*

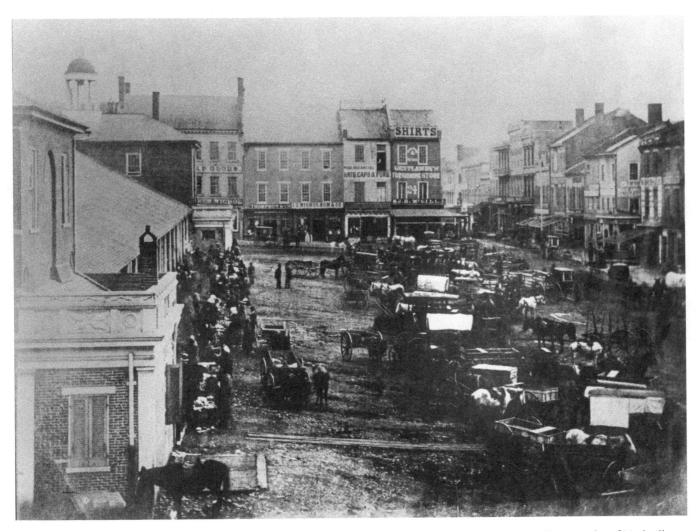

Nashville Town Square showcases horse-drawn wagons in the streets. This is one of the earliest known photographs of Nashville. The Davidson County Courthouse is on the left.

Eve of the Civil War to the Centennial

(1850s–1899)

Hymes School, pictured here, was built in 1857 on the corner of Lime and Summer streets.

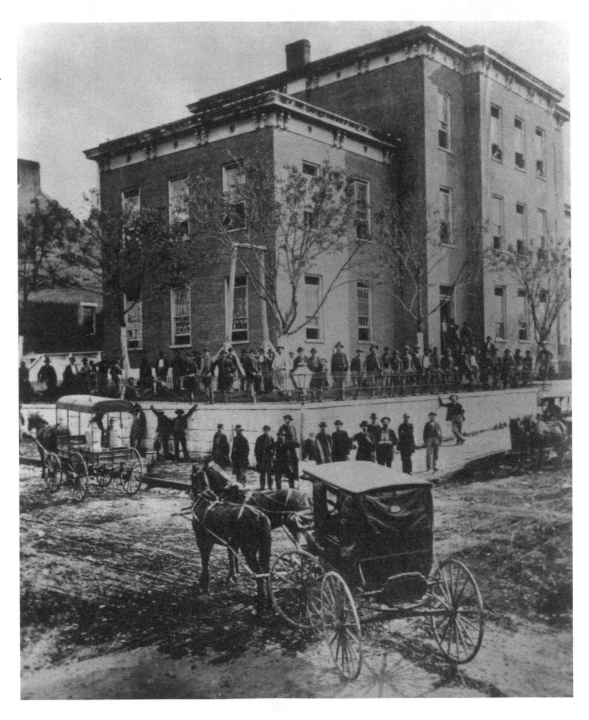

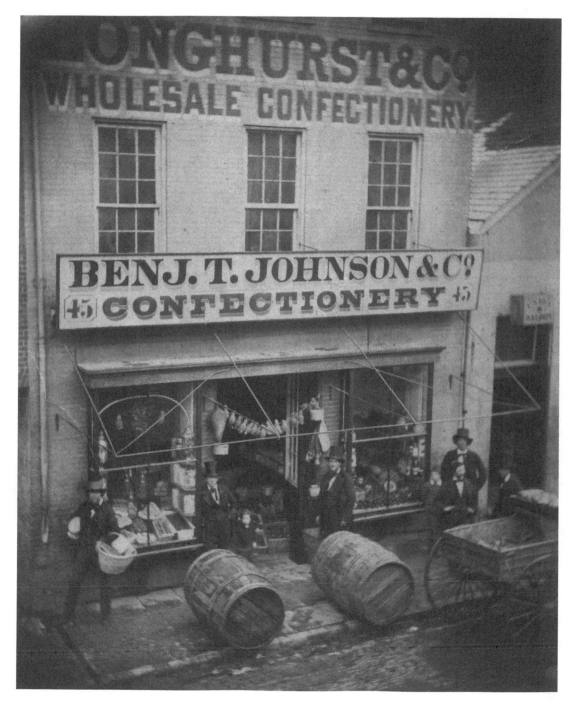

In 1859, men in suits pose for the camera at the storefront of the Benjamin T. Johnson & Company Confectionery.

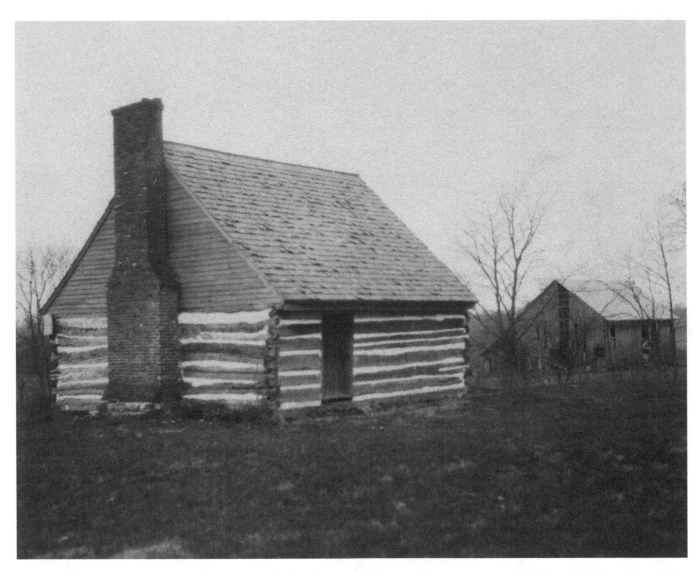

Andrew and Rachel Jackson lived in this log cabin before the Hermitage mansion was constructed. Jackson built the cabin, which originally had two floors, in 1804.

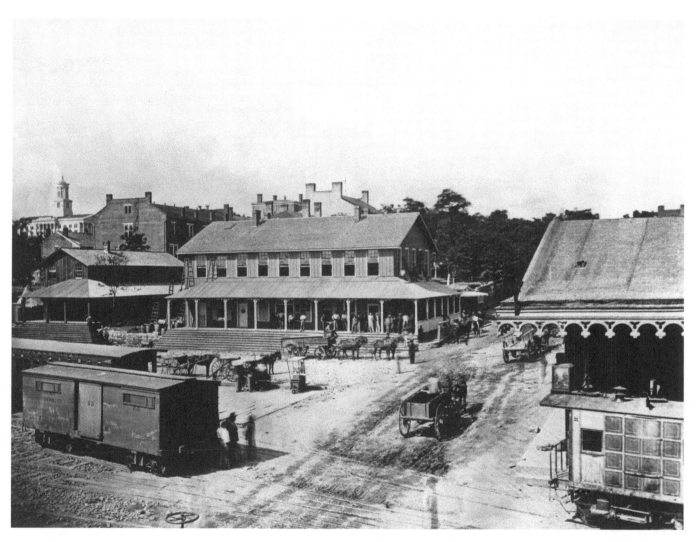

Railroad offices of the Superintendent and Quartermaster of the Military Railway are seen here around 1862. Spring Street is visible on the right. At center, on the hill between the two hip-roofed buildings, the top portion of Polk Place is visible. The State Capitol is on the left.

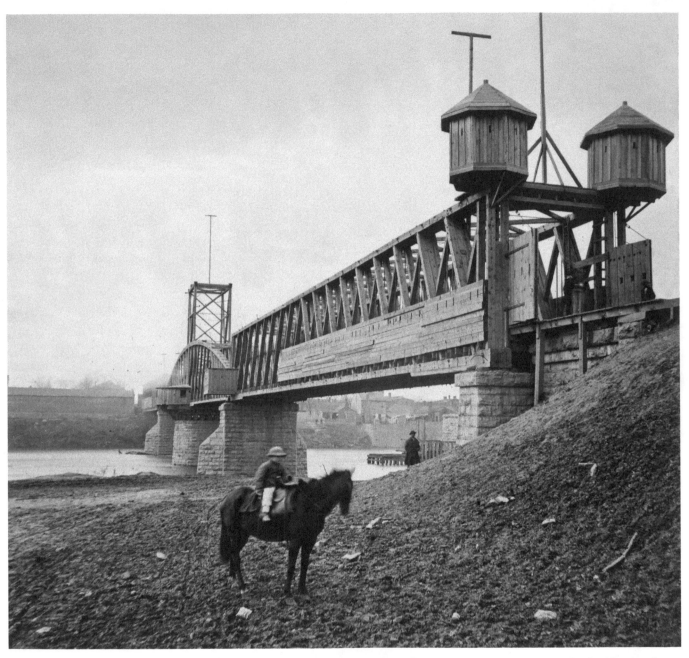

The Cumberland Railroad Bridge was fortified during the Civil War. Perhaps this youngster was supervising the fortification from his horse.

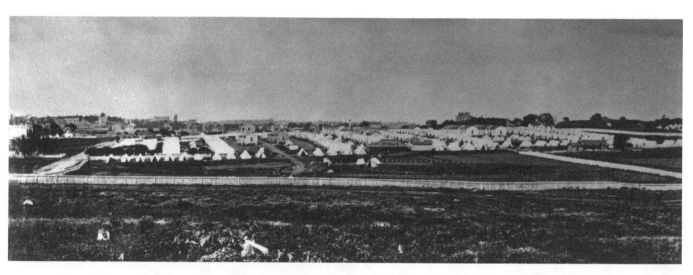

Pictured here around 1862-64 is the Federal Army field hospital on the western outskirts of Nashville. The dirt road on the left is Spring Street leading into town toward the Masonic Hall and the First Presbyterian Church, one tower of which is visible on the horizon.

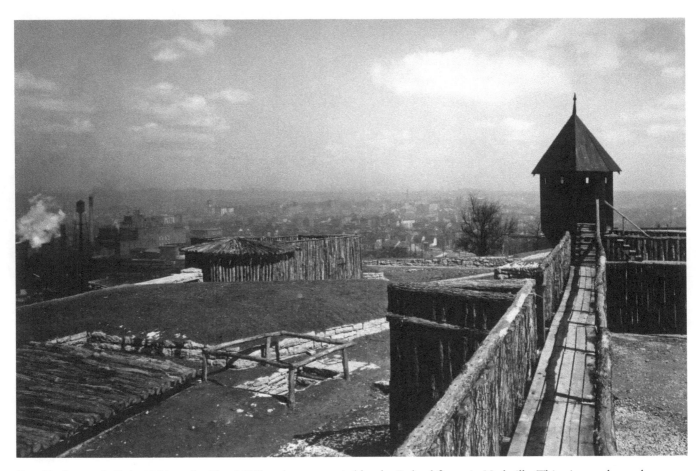

Fort Negley was built in 1862 on St. Cloud Hill and was occupied by the Federal forces in Nashville. This picture shows the reconstructed fort built by the WPA in the 1930s.

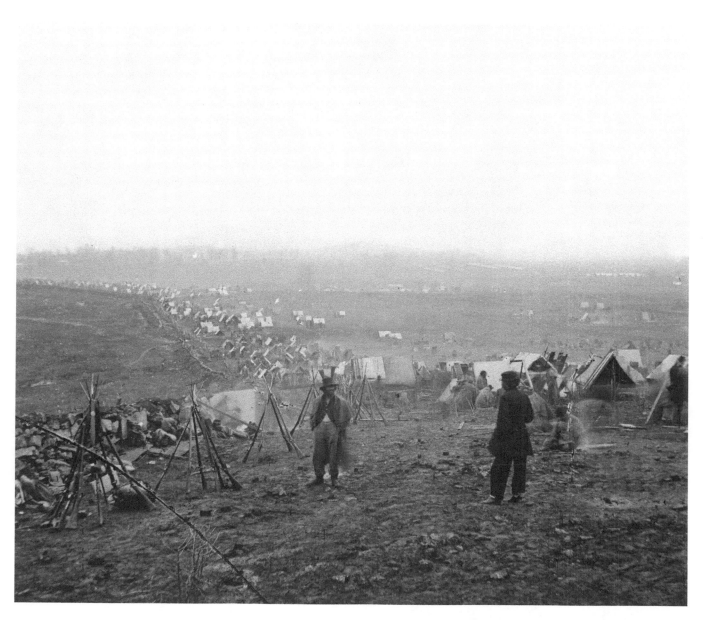

This Federal Army camp in Nashville looks west from near Fort Negley in 1864.

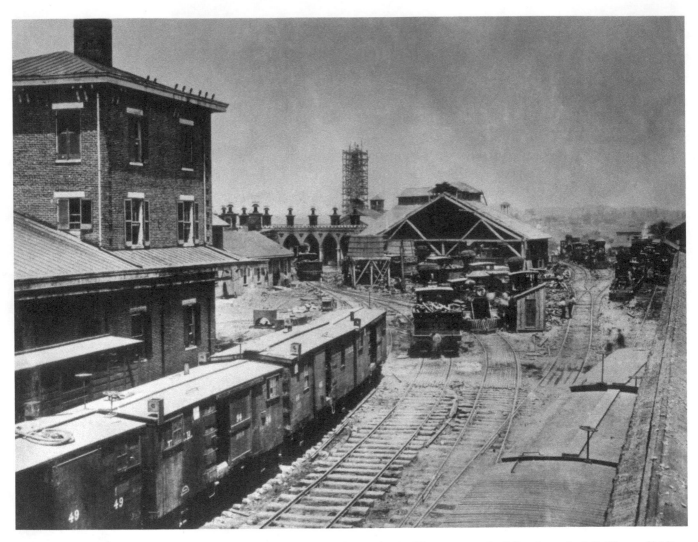

The rail yard of the Nashville & Chattanooga Railroad during the Civil War. The passenger building is on the left. The scaffolding at center, erected by Union forces, is adjacent the roundhouse that was being demolished to make way for a new repair shop.

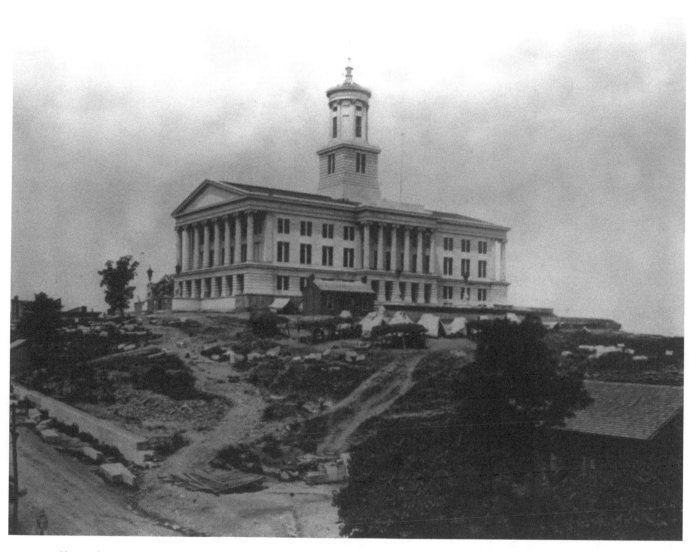

Shown here in 1863 is a military encampment at the foot of the State Capitol, which had been built just prior to the war.

During the Battle of Nashville in 1864, men guard the fortified bridge over the Cumberland River. The battle lasted two days and ended in a major Union victory.

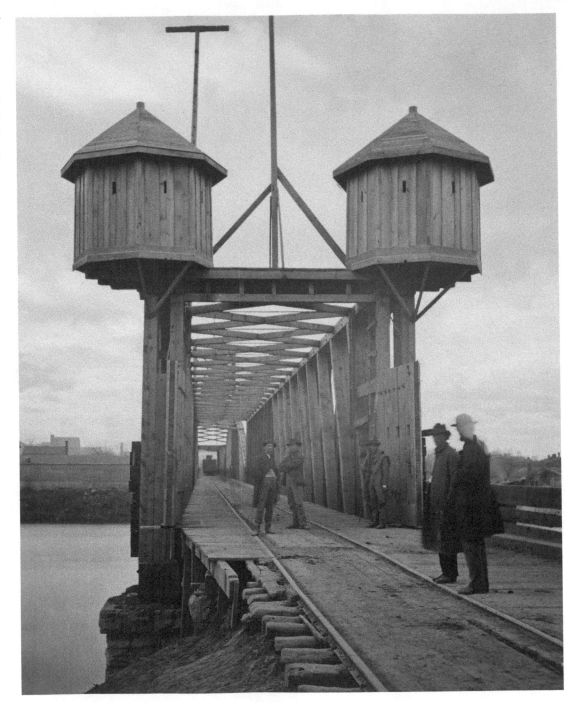

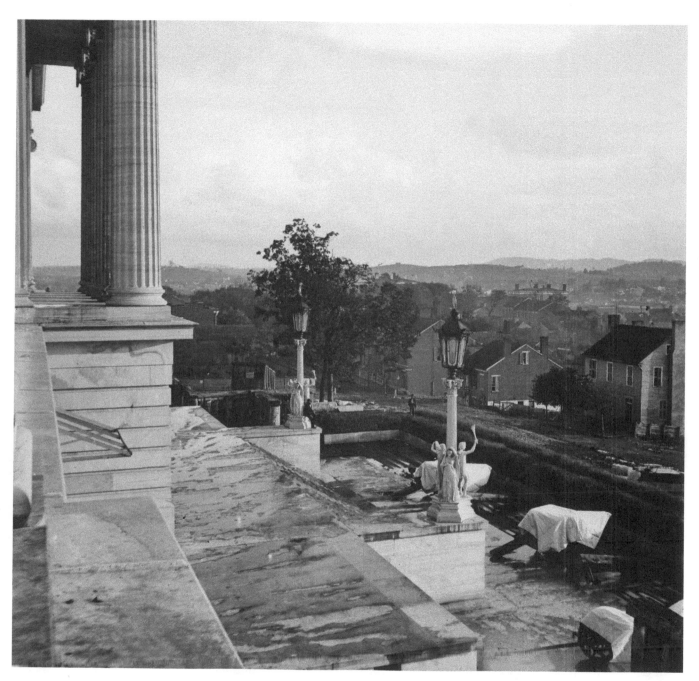

Covered artillery looks down from the steps of the armed Capitol around 1864.

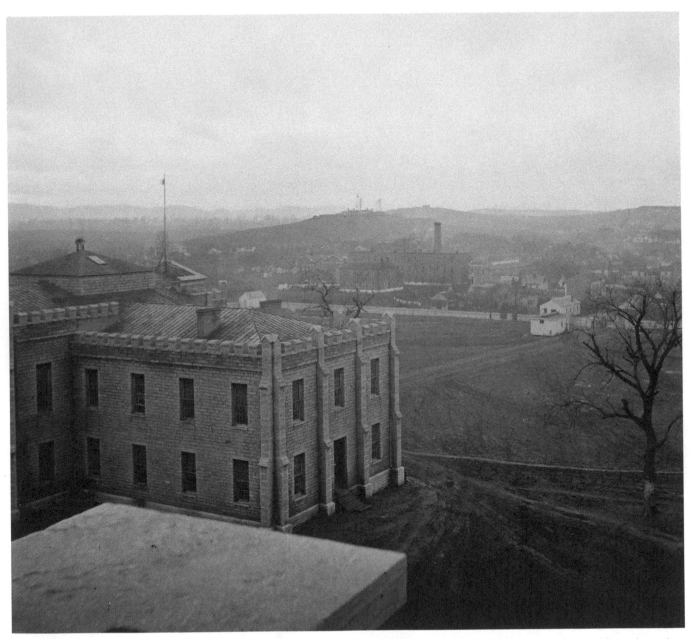

A Civil War photograph taken from the roof of Lindsley Hall shows the three-story College Hill Armory with its tall smokestack in the center, and Fort Negley beyond and slightly to the left. The building in the foreground housed the Literary Department of the University of Nashville.

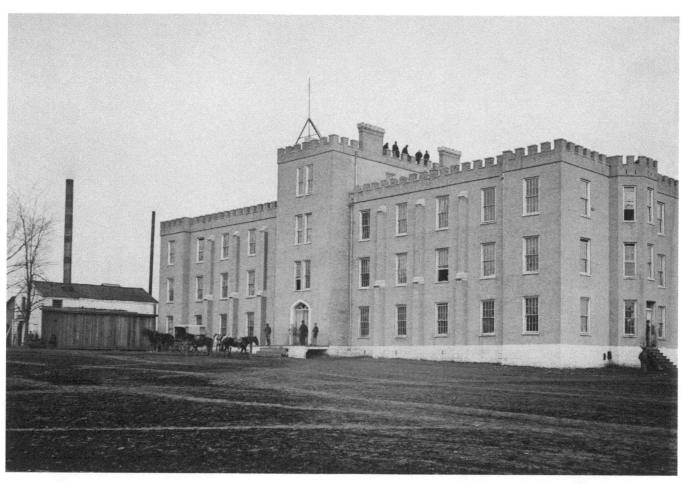

The University of Nashville's Lindsley Hall was built in 1855. During the Civil War, it was used by Confederate and Union forces as a hospital.

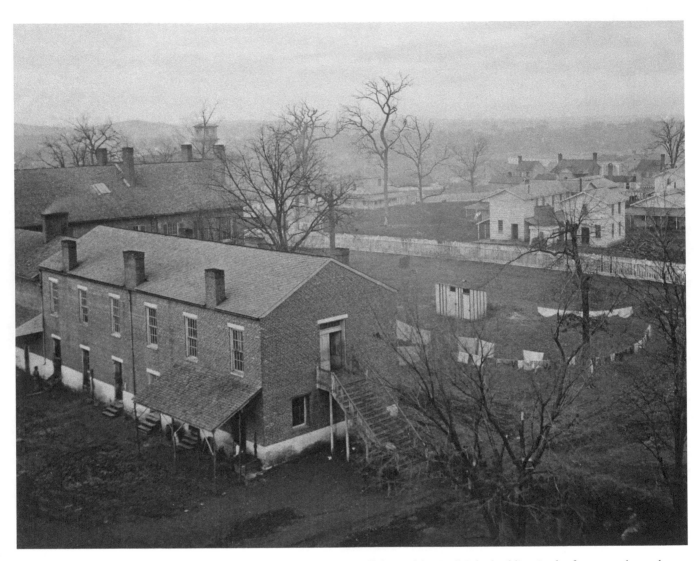

This photograph was taken from the roof of the University of Nashville's Lindsley Hall. The building in the foreground was the home of the University of Nashville's chancellor, John Barrien Lindsley.

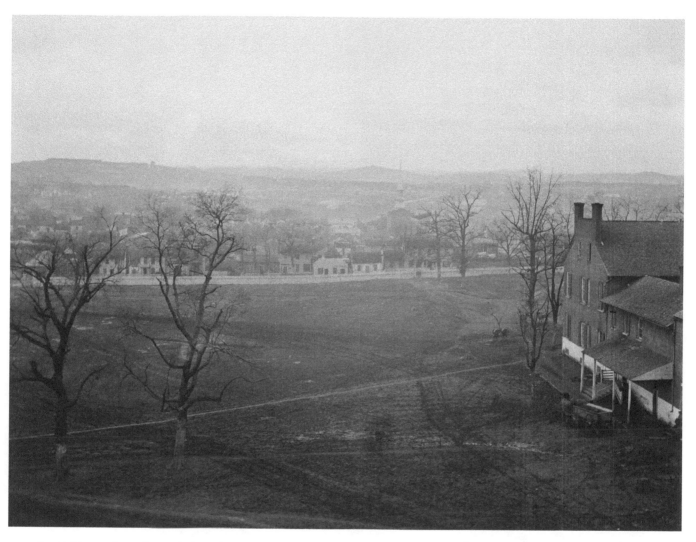

An 1864 view from the roof of Lindsley Hall. Summer Street is obscured by the white-washed plank fence, which defined the University of Nashville's perimeter.

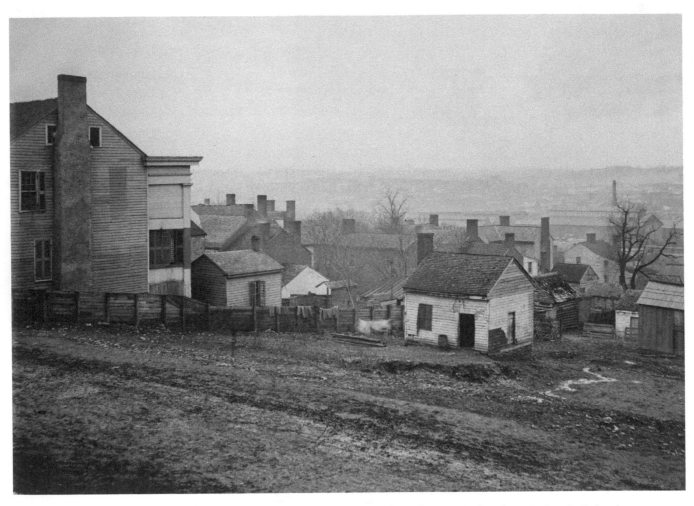

Looking south from Vine Street in 1864. The building down the hill on the right was a railroad repair shop built by the Federal Army.

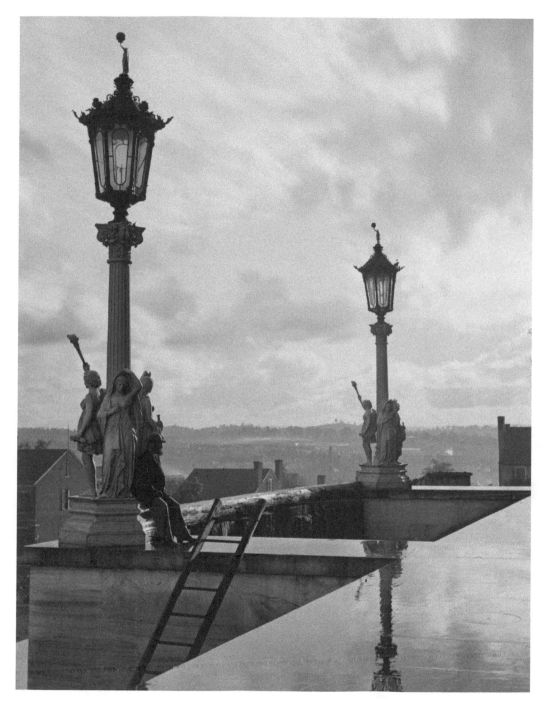

This 1864 view from the State Capitol was recorded on a rainy day. A man is seen resting against one of the statues.

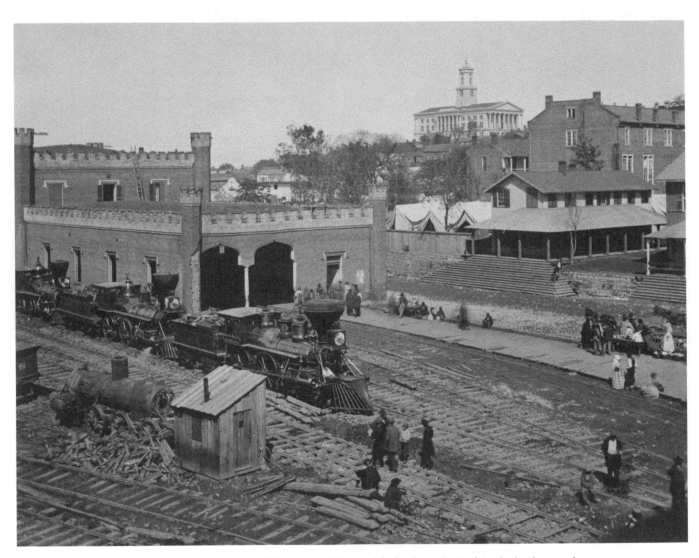

The Nashville & Chattanooga train depot in 1864 is pictured here, with the State Capitol in the background.

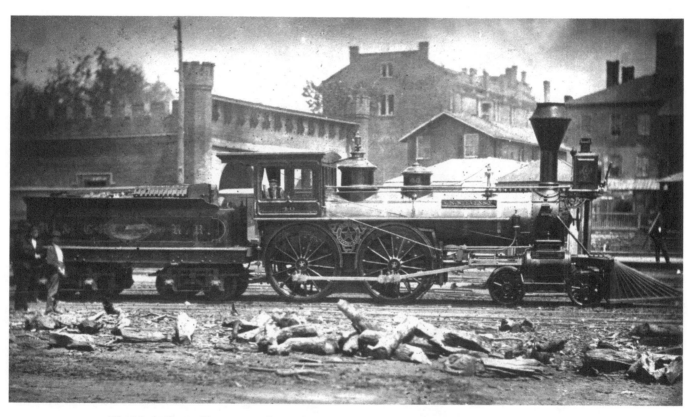

The Nashville & Chattanooga locomotive *V. K. Stevenson* at the Nashville & Chattanooga terminal, circa 1870.

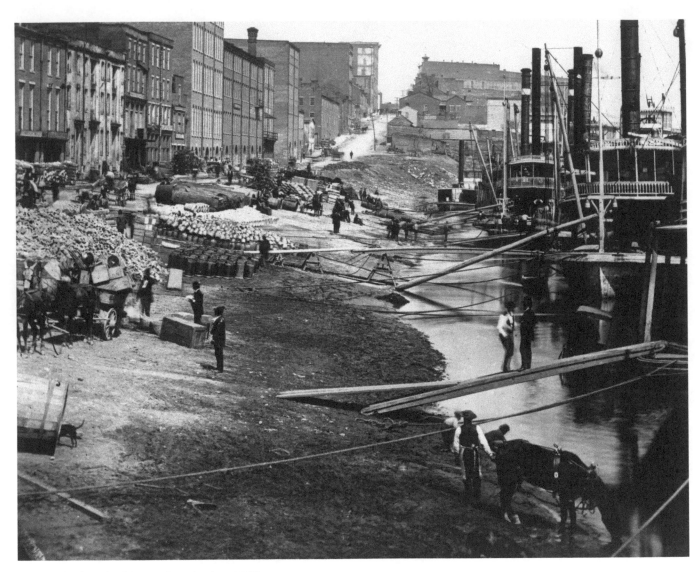

The Nashville Wharf (Front Street), circa 1875.

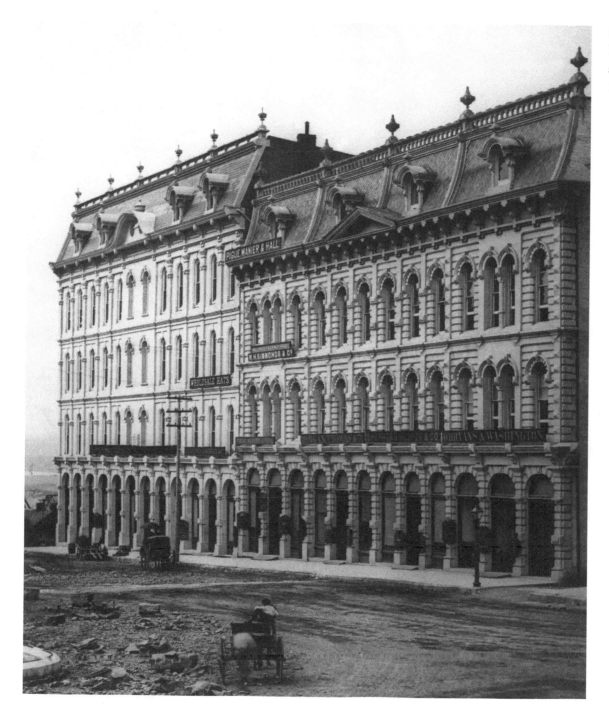

East side of
Nashville's public
square around
1874.

The north side of Union Street around 1875.

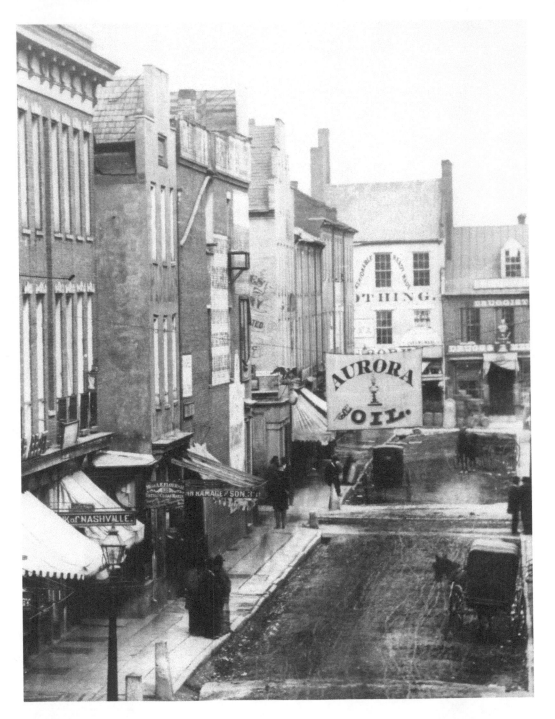

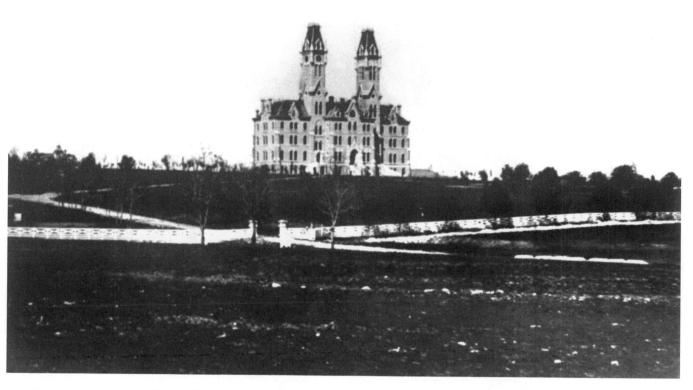

The main entry gate to Vanderbilt University at the end of Broad Street with the Main Building in the background, 1875. The wooden fence was built around the campus to prevent livestock from intruding. The stone gateposts remain today.

First Baptist Church,
Summer Street, circa
1880.

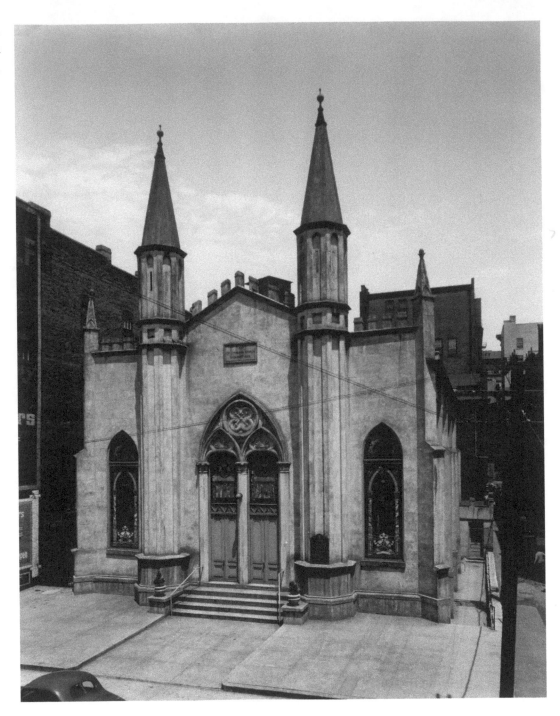

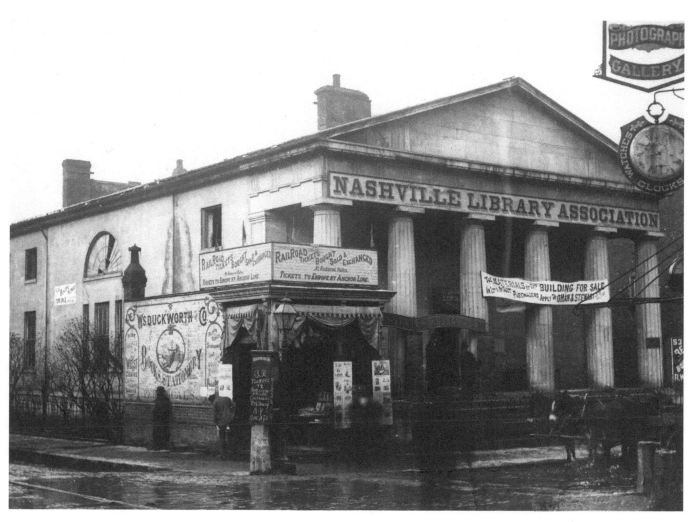

The Nashville Library Association is shown here at the corner of Cherry Street (Fourth Avenue) and Union Street in 1881.

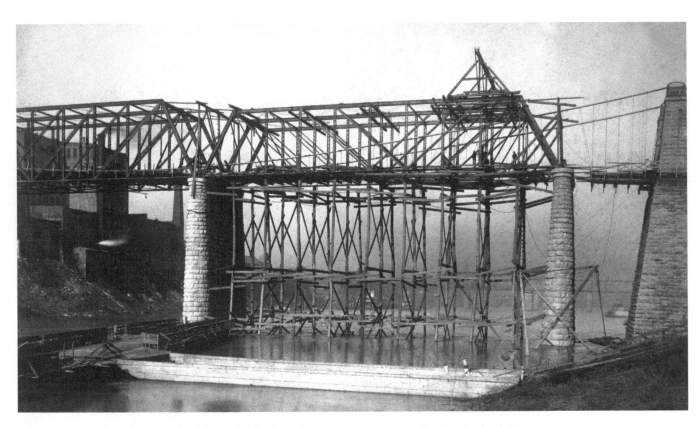

Downtown in 1885, the Woodland Street Bridge is under construction across the Cumberland River.

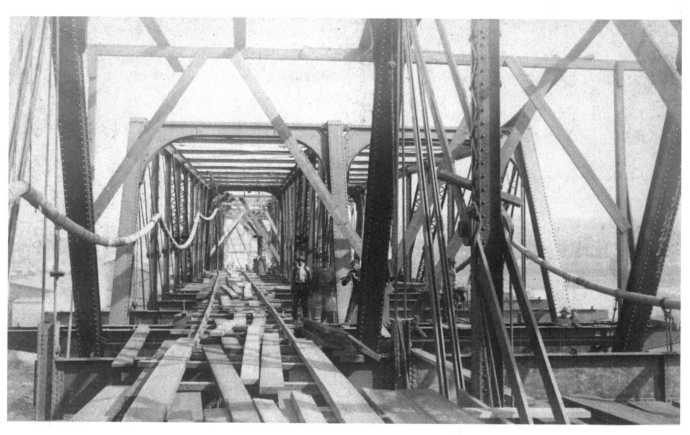

This 1885 close-up of the Woodland Street Bridge under construction depicts men standing on planks among the cables.

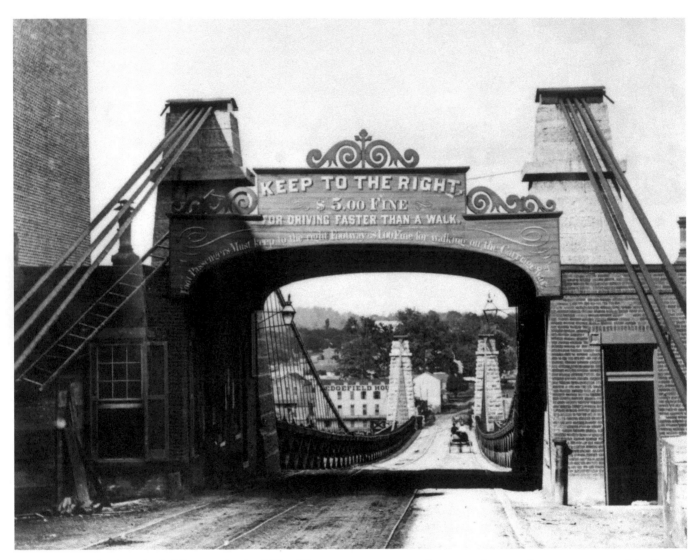

The suspension bridge rebuilt following the Civil War. The masonry towers on the west and east ends were remnants of the first suspension bridge, destroyed by retreating Confederate forces in February 1862.

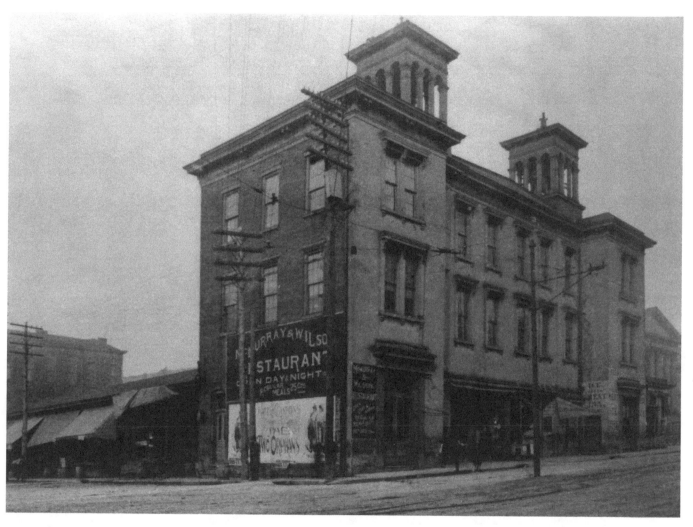

A later view of the Nashville Market House, circa 1875-85. This photograph was taken after the introduction of electricity in Nashville. McMurray & Wilson's offers "regular meals" for 25 cents.

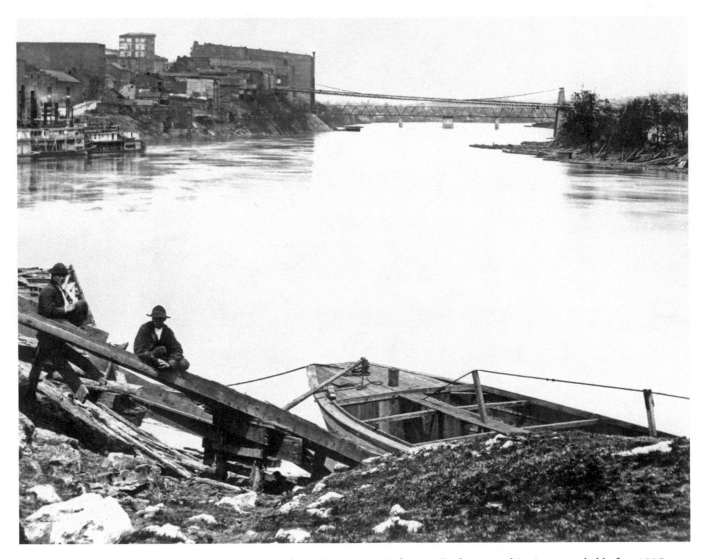

The Cumberland River, just below the current site of the Shelby Street Pedestrian Bridge, is in this view recorded before 1885. The suspension bridge at Woodland Street is in the background.

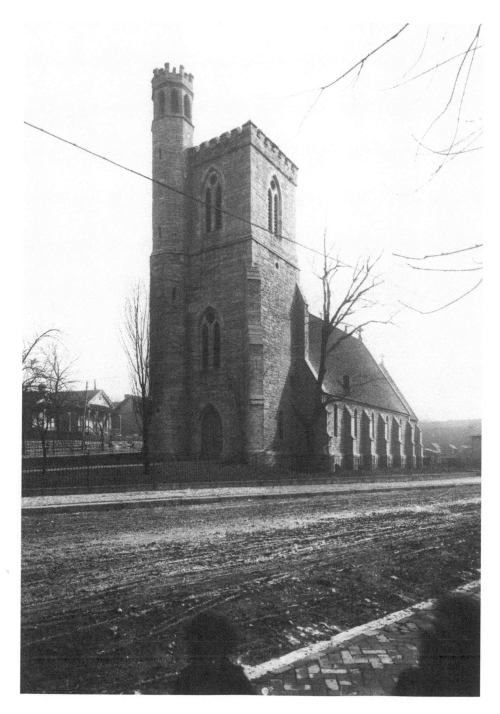

Holy Trinity Church, circa 1887. During the Civil War, the altar was used as an operating table by the Union Army. This building still serves the congregation meeting there today.

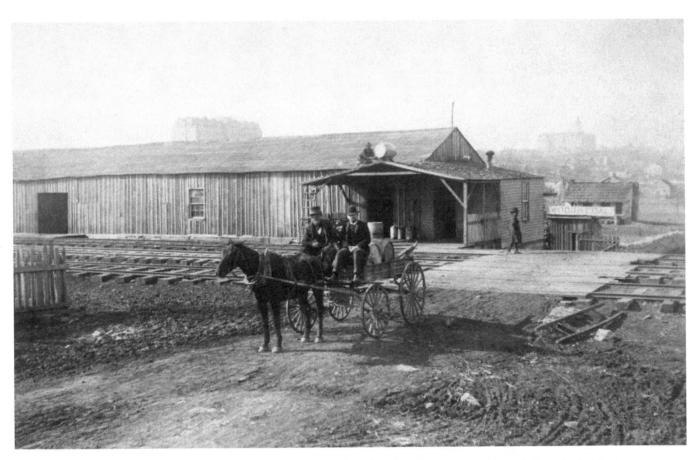

This view of the Nashville Railway Yard shows Fisk's Main Building (left) and Fisk Jubilee Hall (right) on the hill in the background. The cornerstone of the Main Building was laid in 1873. Jubilee Hall was completed two years later.

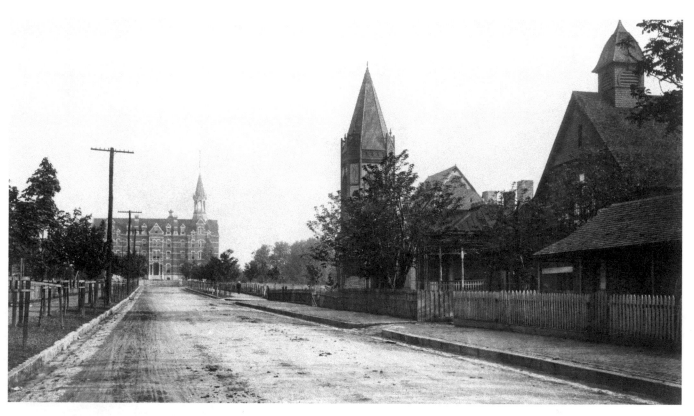

Addison Avenue on the Fisk University campus in 1899. Fisk Jubilee Hall stands at the end of the street, and Fisk Memorial Chapel, with its distinctive tower, is on the right.

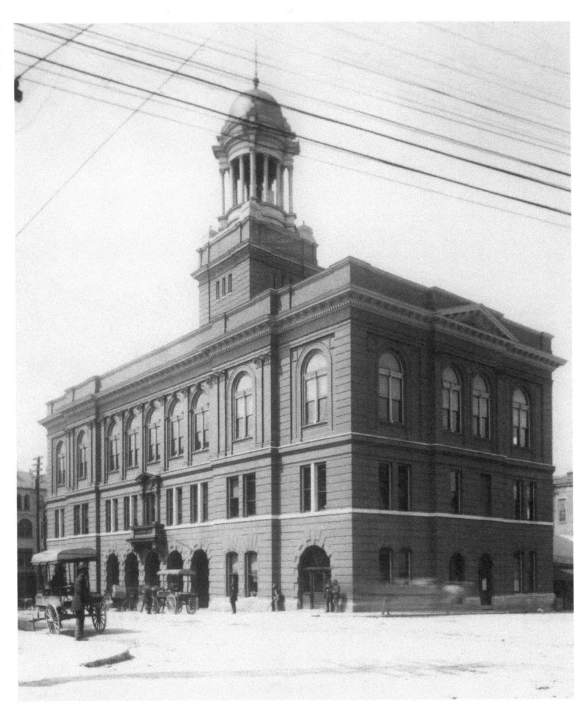

Nashville's City Hall faces Deaderick Street in 1890.

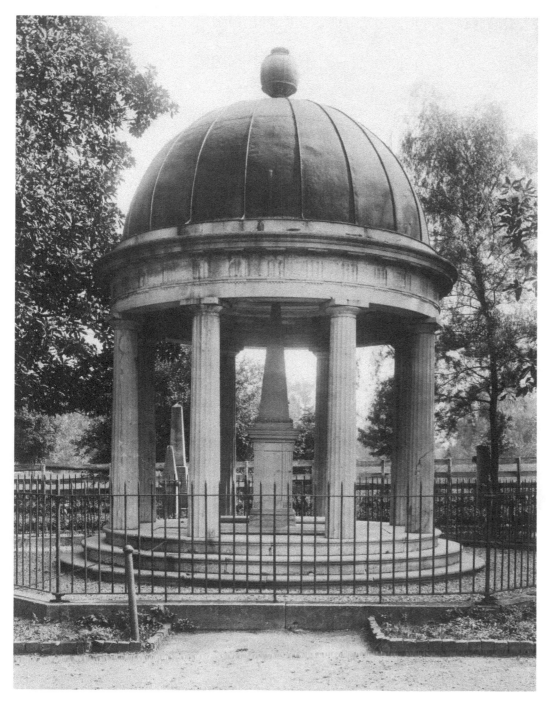

President Andrew Jackson's Tomb, located in the gardens of the Hermitage. Andrew's wife, Rachel Donelson Jackson, died in 1828 just before Andrew took the oath of office. His niece Emily Donelson served as First Lady during his presidency. Andrew was buried next to Rachel in 1845.

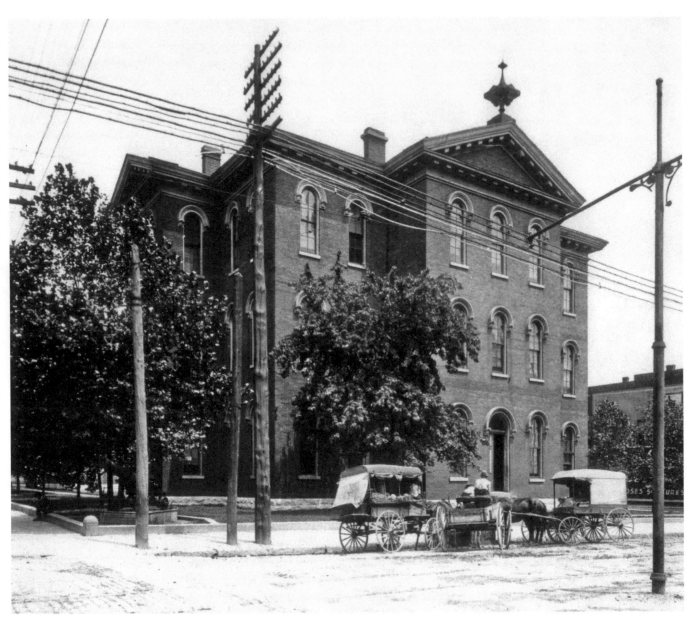

Nashville's first public school, Fogg School, opened February 26, 1855, in this building on the northeast corner of Broad and Spruce streets.

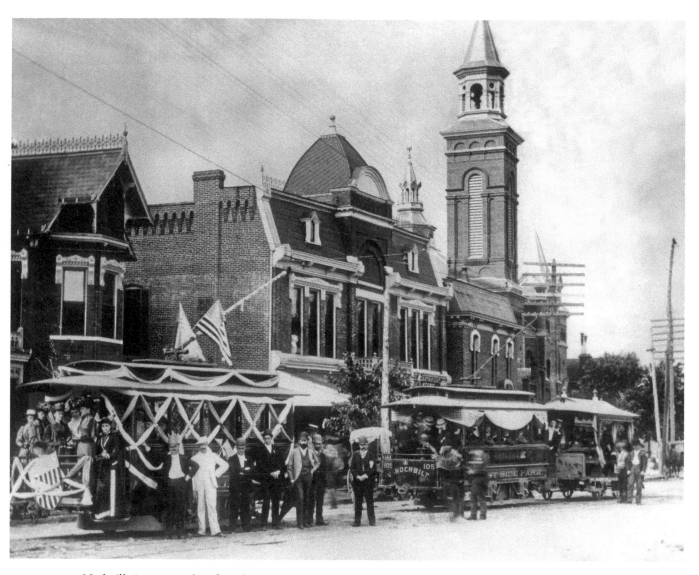

Nashville inaugurated its first electric streetcar service on April 30, 1889. This photograph, taken that day, shows the Vanderbilt and West Side Park streetcar in front of West End Methodist Episcopal South Church on the corner of Mulberry and Broad streets.

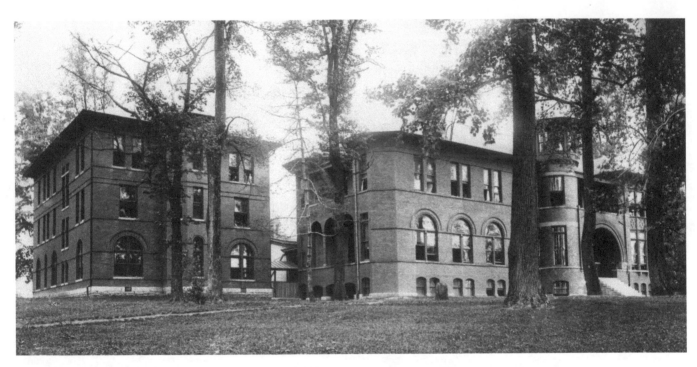

Boscobel College for Young Ladies located in East Nashville.

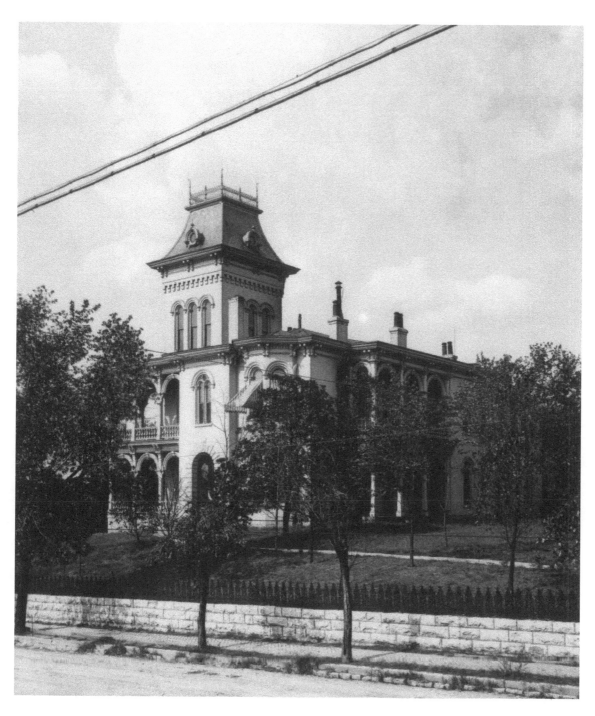

The Douglas
Sanitarium.

High Street in the
late 1800s.

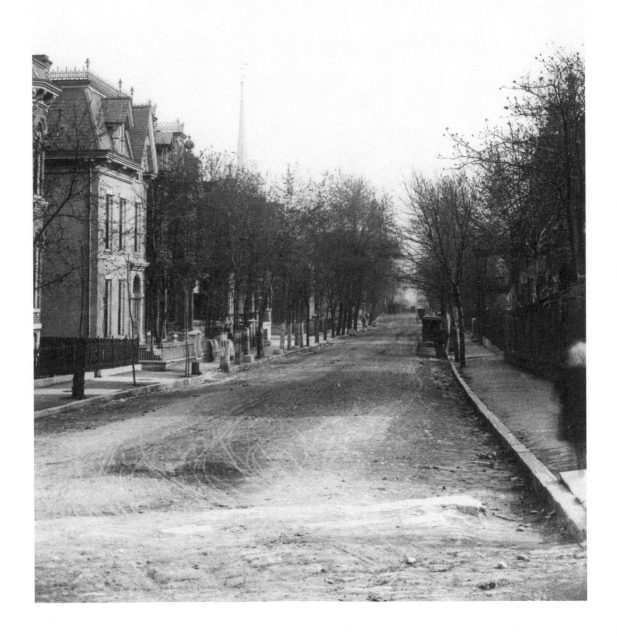

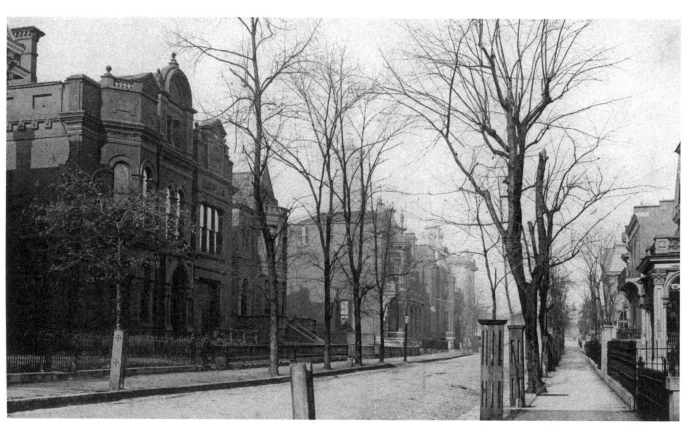

High Street (today known as Sixth Avenue North), in 1894.

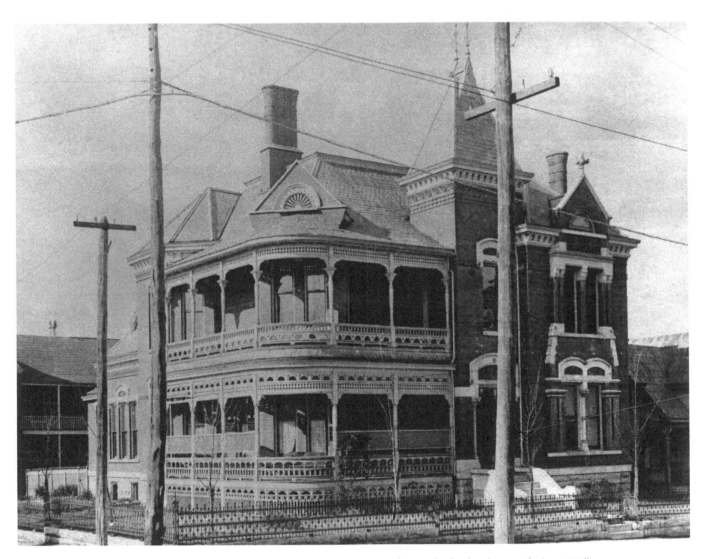

Dr. William T. Briggs' Infirmary on South College Street stands opposite the medical school grounds (ca. 1894).

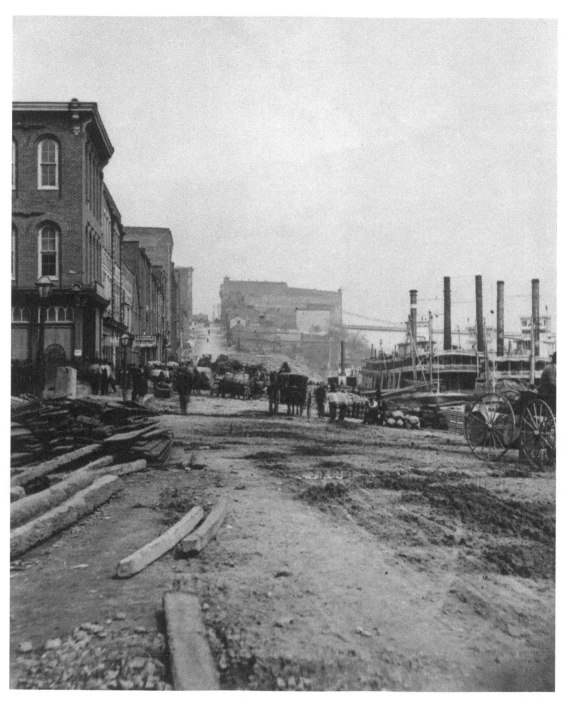

Front Street along the riverfront is unpaved in this photograph from the late 1800s.

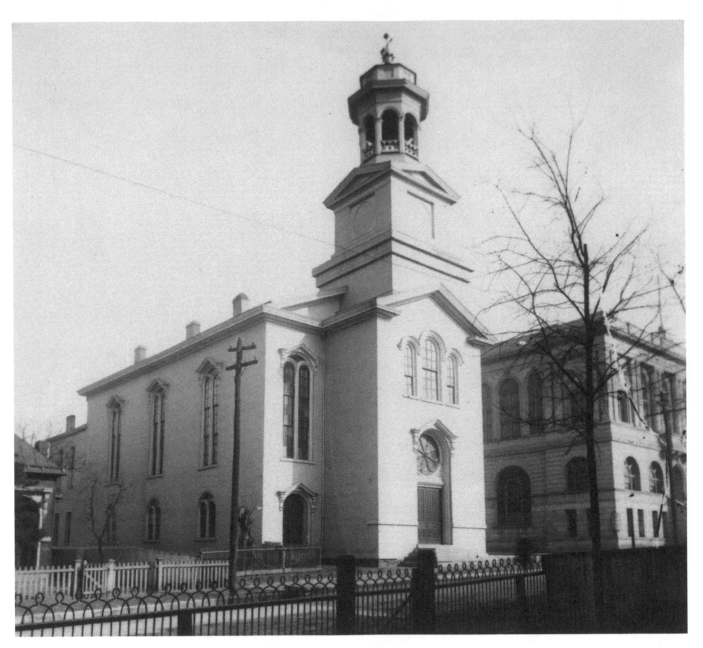

Constructed in the late 1850s, the Elm Street Methodist Church is still a landmark, although it lacks a steeple. It now serves as home to the Tuck Hinton Architectural Firm. To the right is the Medical Department of Vanderbilt University, constructed in 1895 at the corner of Fifth and Elm.

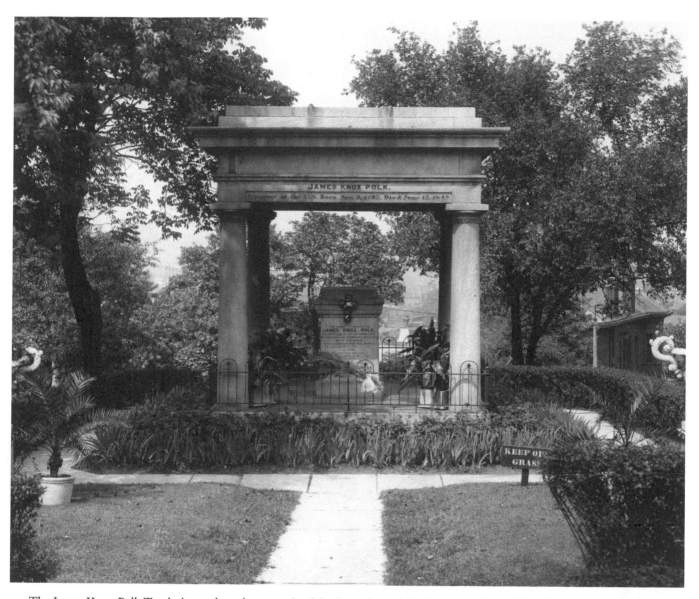

The James Knox Polk Tomb, located on the grounds of the State Capitol. Polk was president of the United States from 1845 to 1849. He and his wife, Sarah, were originally buried in the garden of their mansion, Polk Place, close to North Vine Street (now /th Avenue North). They were re-interred on the State Capitol grounds in 1893.

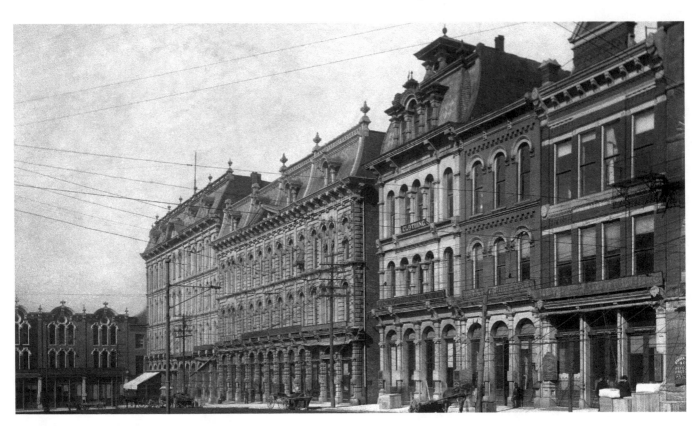

East side view of Nashville's public square, circa 1898.

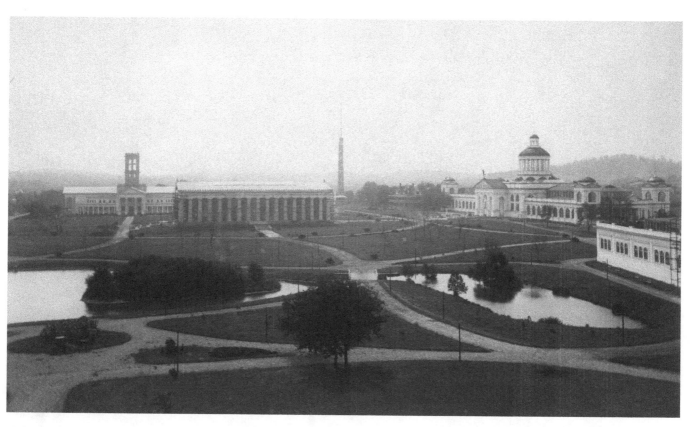

The Tennessee Centennial Exposition of 1897, featuring many buildings with Lake Watauga in the foreground. The Parthenon is flanked by the Auditorium on the left and the Commerce Building on the right.

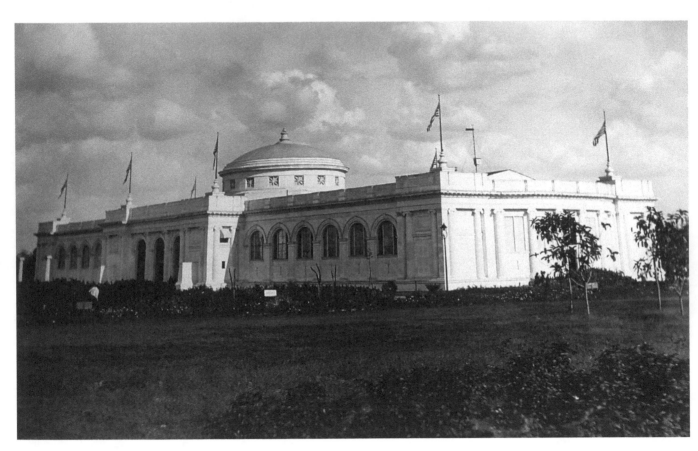

The Government Building at the Centennial Exposition.

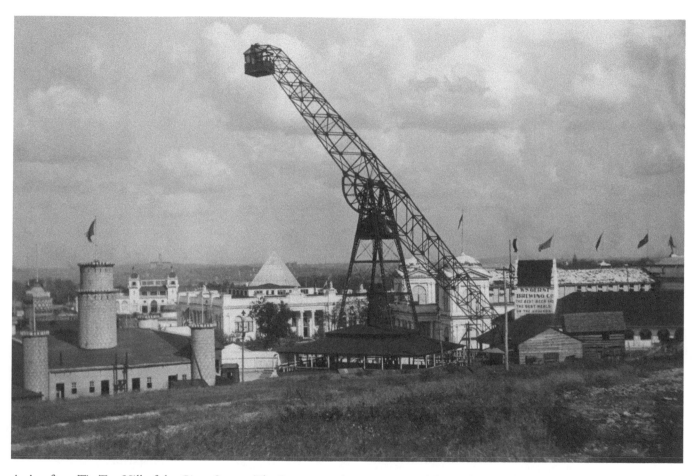

A view from Tip Top Hill of the Giant Seesaw. The Seesaw was the centerpiece of the Midway at the Centennial Exposition. It was later dismantled and reassembled in Omaha for that city's Trans-Mississippi Exposition, where it also proved popular.

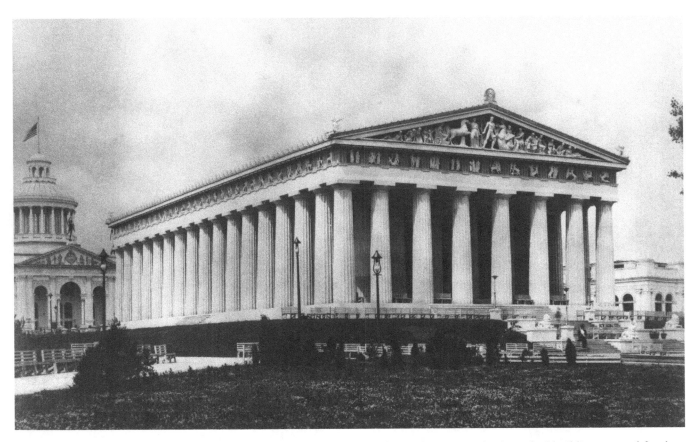

The Parthenon during the Tennessee Centennial Celebration of 1897. The Parthenon was the first of 36 buildings erected for the exposition. The Commerce Building is visible at left.

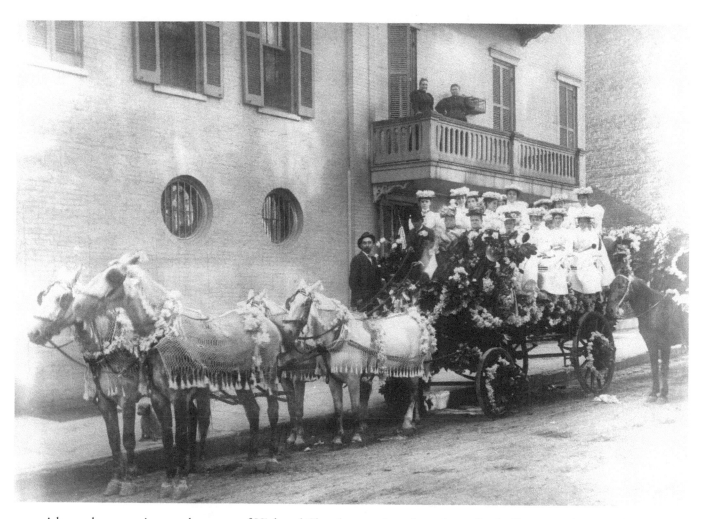

A horse-drawn carriage on the corner of High and Church streets is ready to depart for the Tennessee Centennial Exposition.

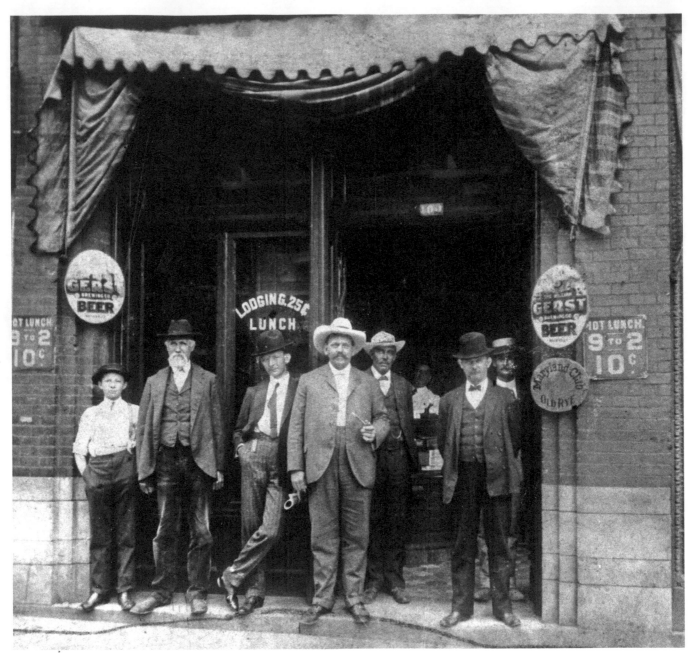

The storefront of the Silver Dollar Saloon at the corner of Second Avenue and Broadway advertises Gerst Beer and a hot lunch for ten cents in 1900. Gerst Beer was brewed locally.

At the Turn of the Century

(1900–1916)

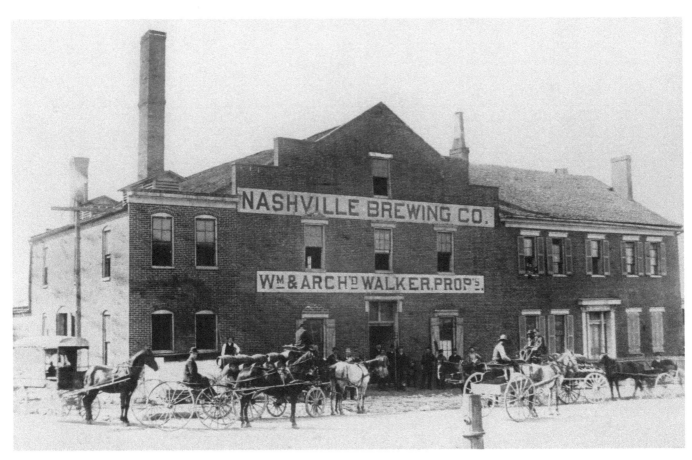

Nashville Brewing Company is shown here around 1900.

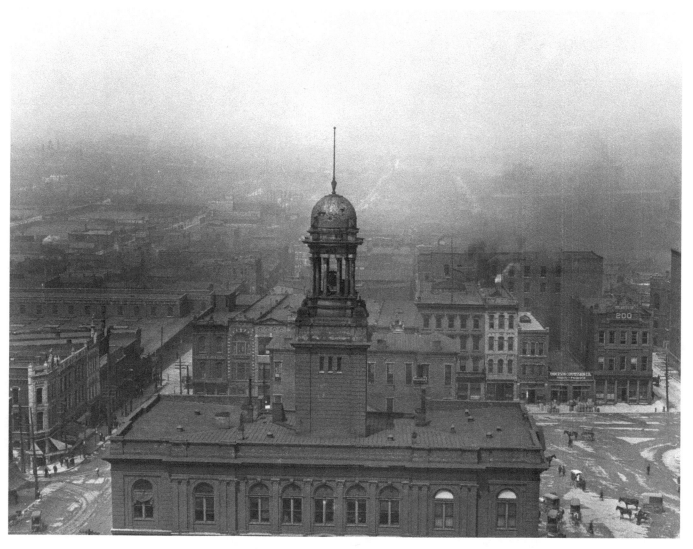

The old City Hall building rises in the foreground in this winter image facing north.

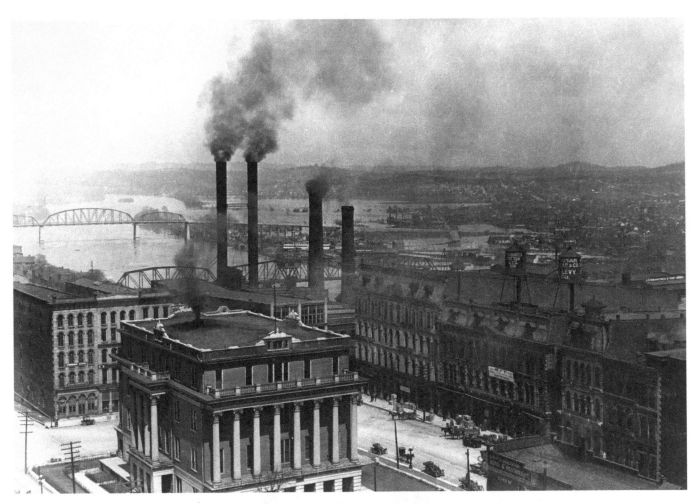

The downtown Courthouse with the railroad bridge and the Jefferson Street Bridge in the background, circa 1915.

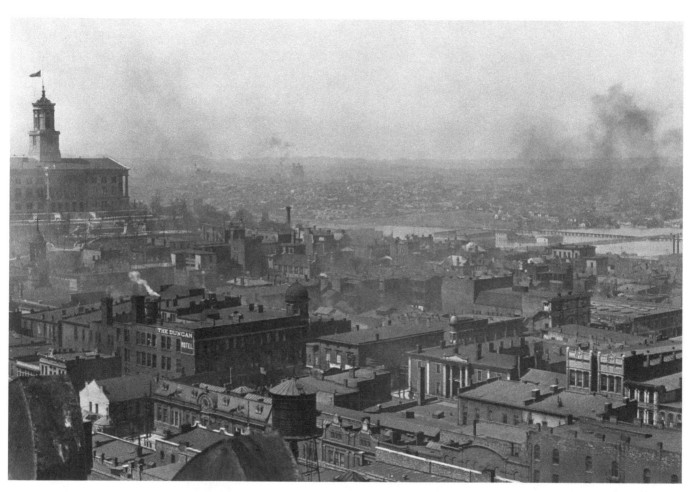

Downtown view showing the State Capitol and the Duncan Hotel. The hotel, at left-center, can be identified by its small dome.

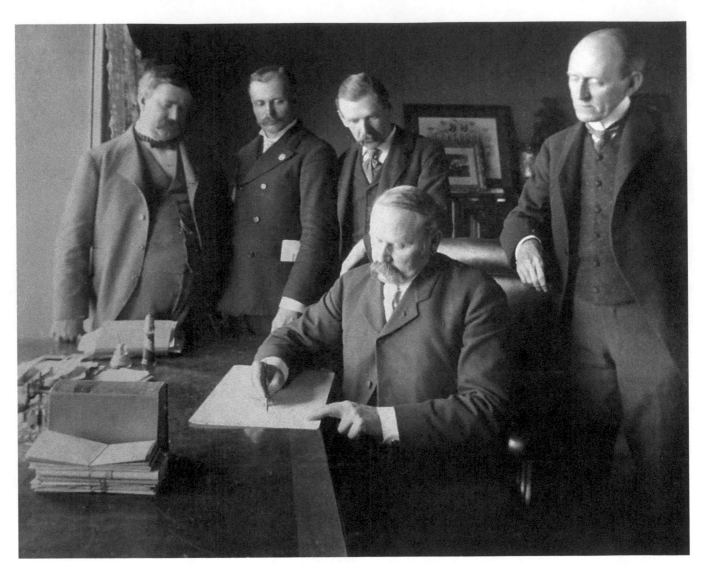

Governor Benton McMillin signs the Child Labor Bill in 1901.

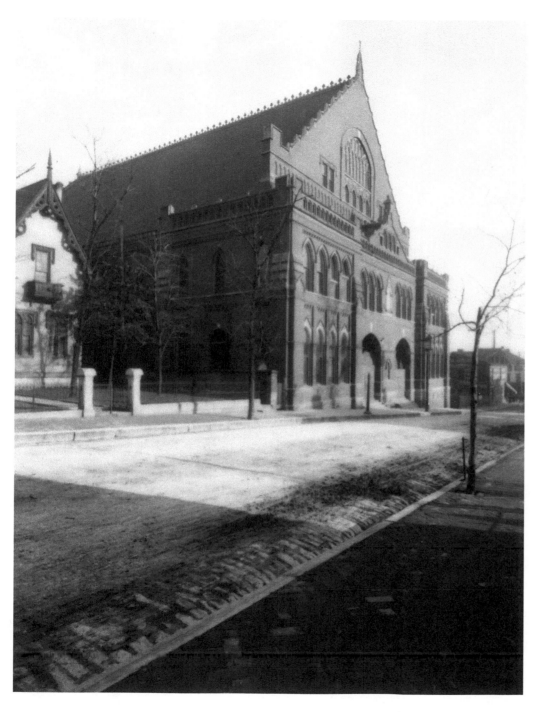

Union Gospel Tabernacle (Ryman Auditorium), circa 1900. The tabernacle was envisioned by riverboat captain Thomas Green Ryman after he was converted by southern evangelist Samuel Porter Jones. The first revival was held within its walls in May 1890.

Union Street showcases several businesses including Huellebrand Brothers Jewelry and Keith Simmons Hardware, at 316-318 Union Street, in 1906.

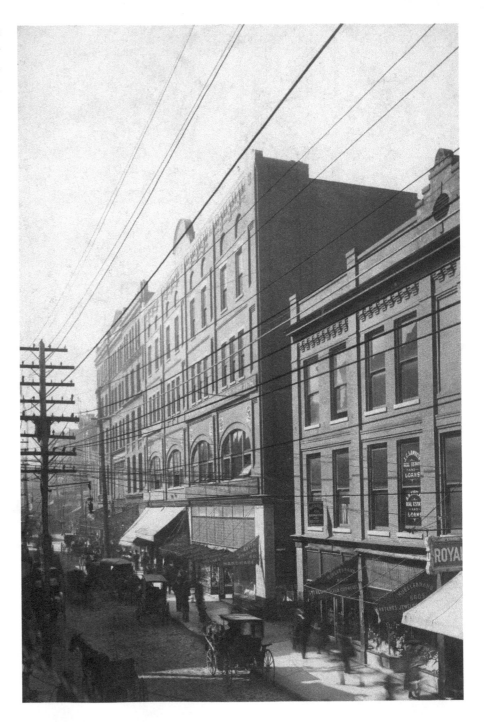

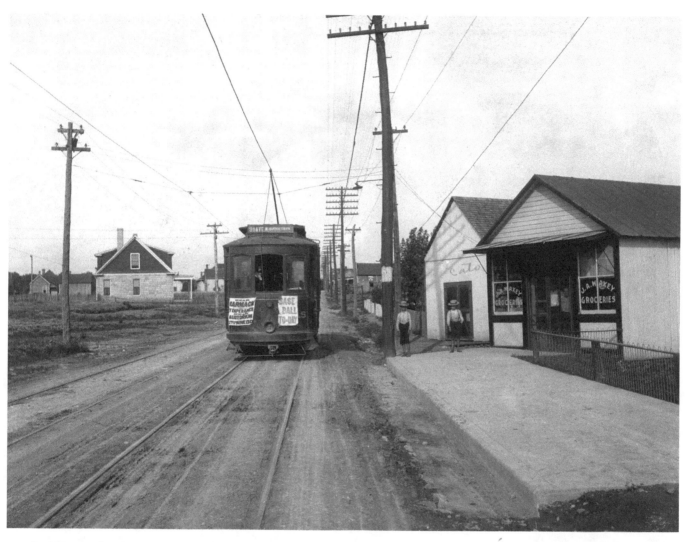

In 1907, an electric streetcar rolls down Buchanan Street advertising baseball games and an Edward W. Carmack speech at the Ryman in favor of prohibition.

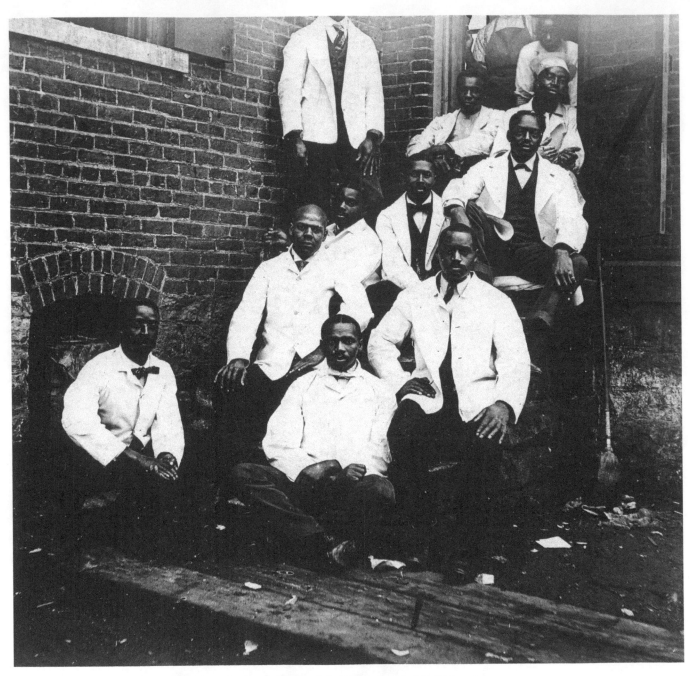

Cooks, porters, and servers are seated on the steps of West Side Hall at Vanderbilt University.

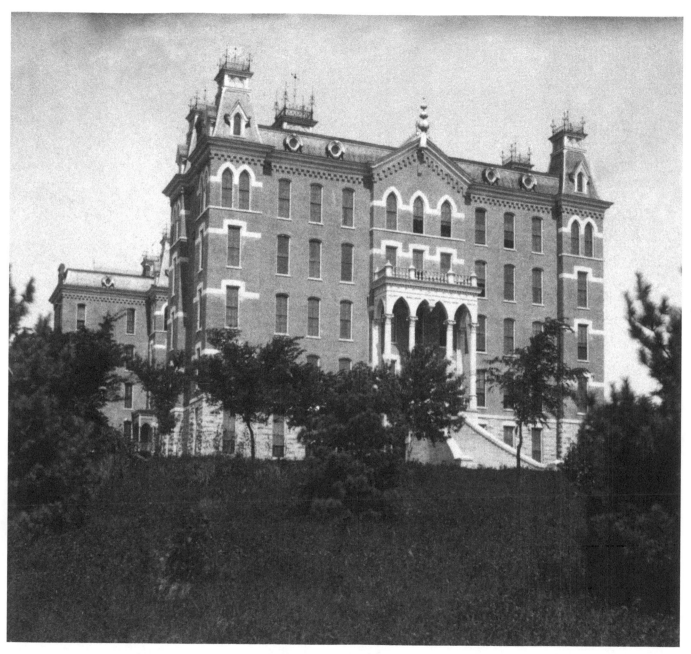

Established as the Biblical Department of Vanderbilt University in 1875, the Divinity School was housed in Wesley Hall from 1880 to 1932.

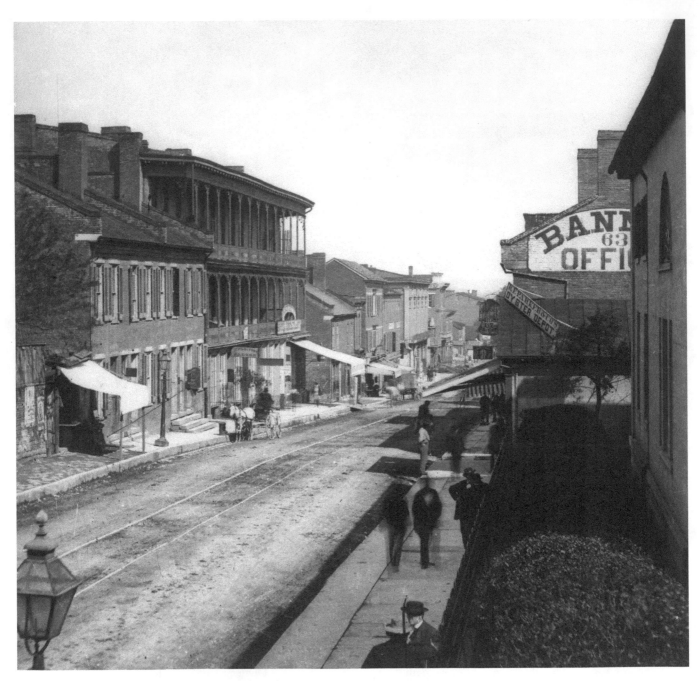

Cherry Street (Fourth Avenue), facing north from Union Street.

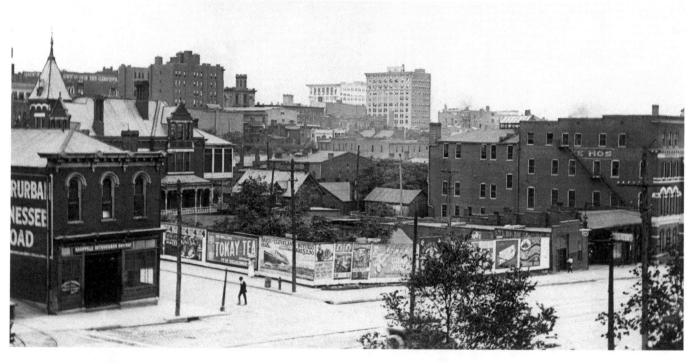

This view overlooks Seventh Avenue and Broadway around 1910. Billboards advertise products like Armour Grape Juice and Tokay Tea. The Jackson Building is visible to the left of the tower of First Presbyterian Church.

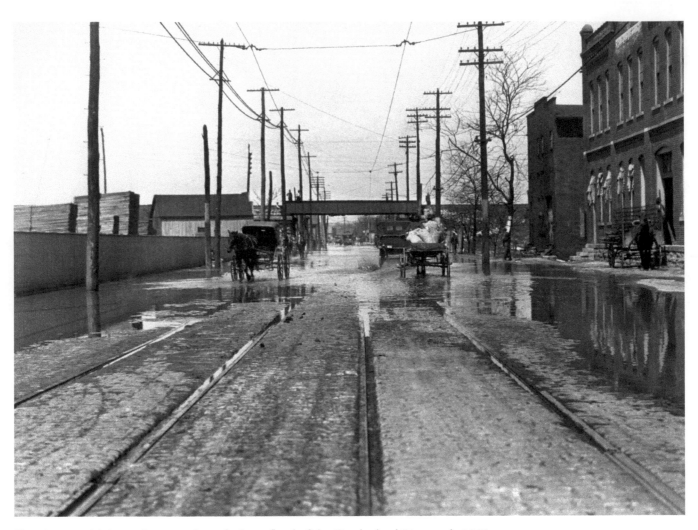

First Avenue with horse-drawn carriages during a flood of the Cumberland River, early 1900s.

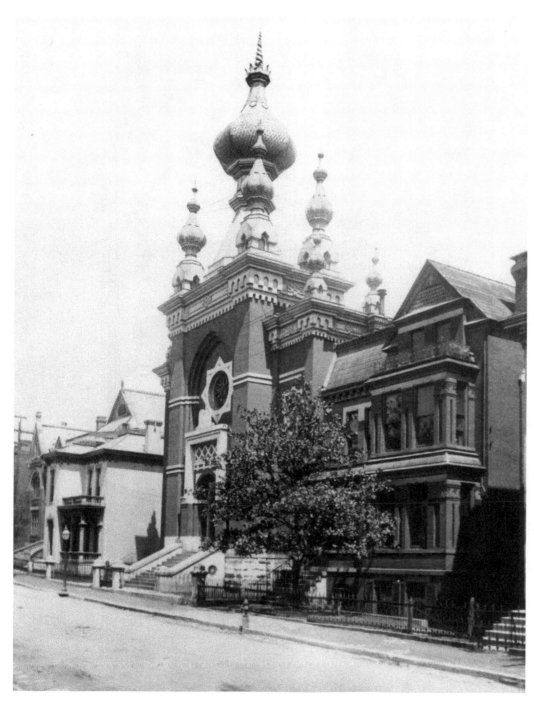

The Vine Street Temple (Synagogue), located on Vine Street (Seventh Avenue North). Its first cornerstone was laid in 1874 with former President Andrew Johnson in attendance for the event. The building was demolished in 1954.

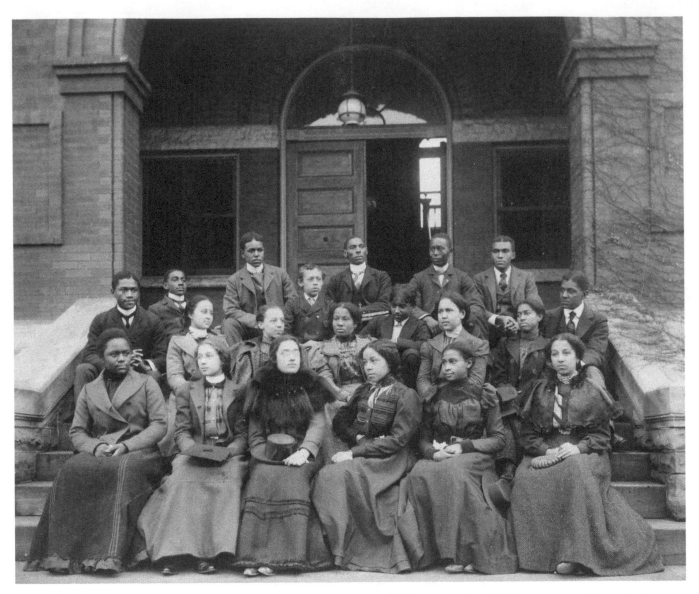

The 1909 Fisk University prep class. The school was named after General Clinton B. Fisk of the Tennessee Freedmens Bureau. According to this photograph, the 1909 class appears to have included more female students than male.

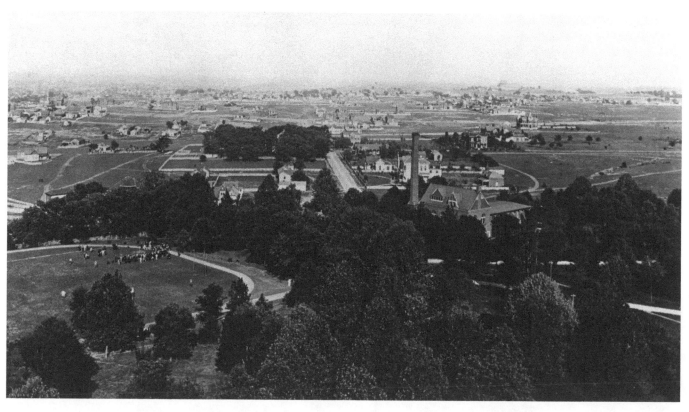

A view from the top of Vanderbilt's University Hall looking toward Nashville's downtown. Broad Street is at center, beyond the Mechanical Engineering Building with its smokestack, erected in 1888. Vanderbilt's original athletic field is visible in the left foreground.

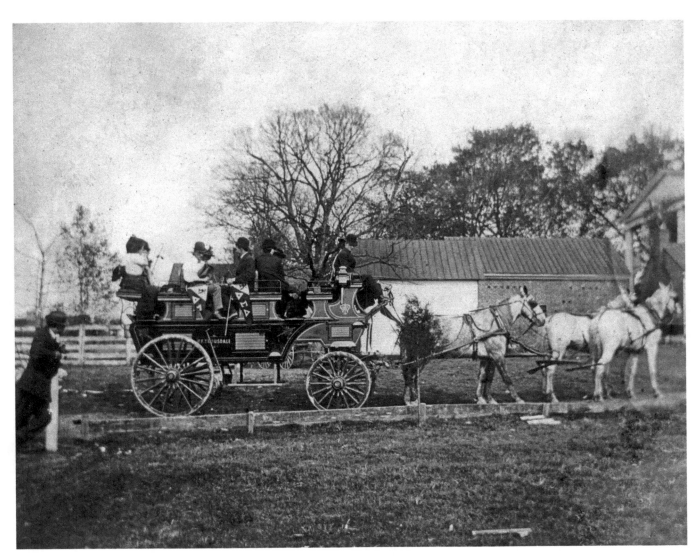

The Hermitage horse carriage, circa 1907-9.

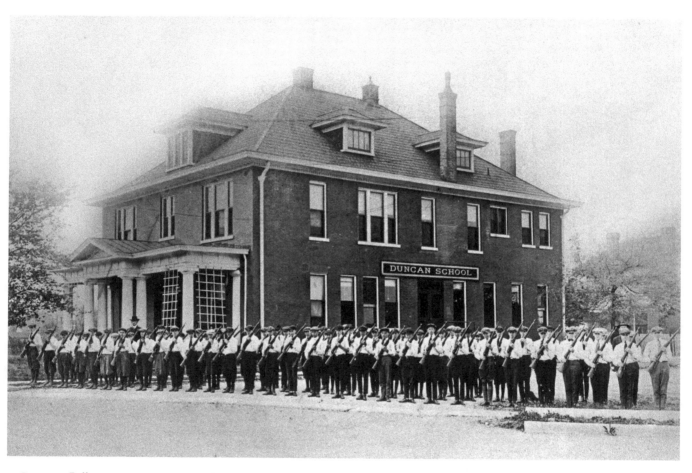

Duncan College Preparatory School for Boys was founded in 1908. The school was located on 25th Avenue South and closed in 1952. The school graduated some 752 men and 6 women, including many community leaders.

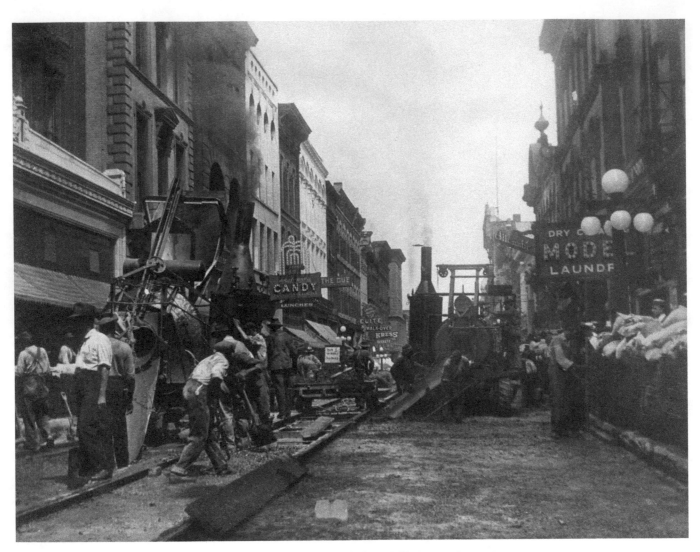

In this view north from Church Street, streetcar tracks are being laid on Fifth Avenue in 1910.

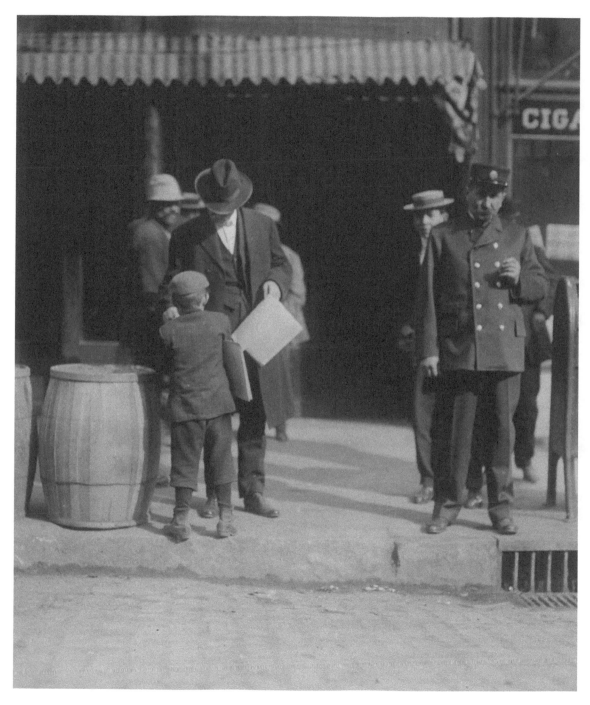

A newsboy sells
a paper to a
businessman.

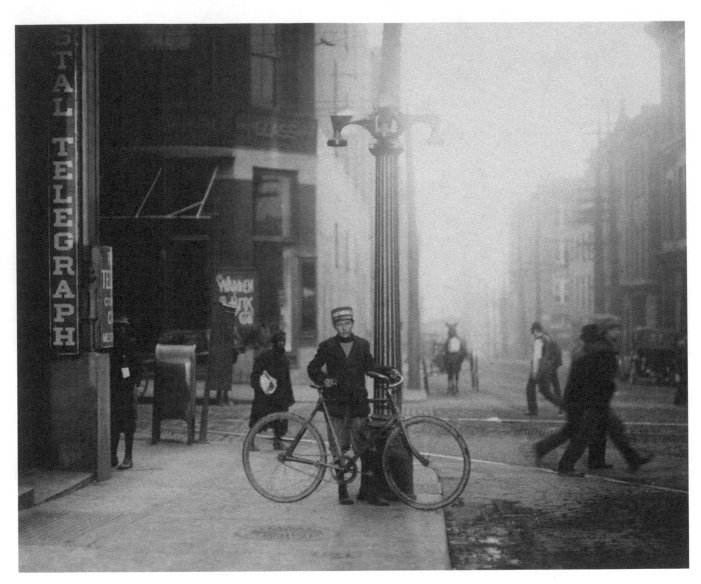

An early postal telegrapher. Four modes of transportation are captured in this 1910 photograph.

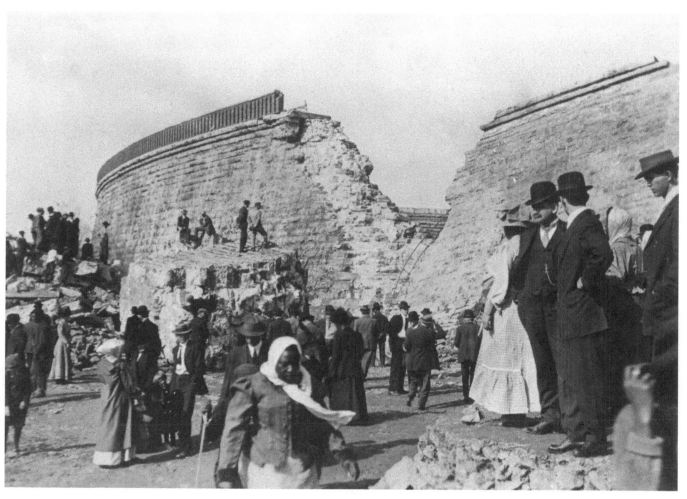

The reservoir break of 1912 flooded part of South Nashville with millions of gallons of water. The reservoir was repaired and is still in use today.

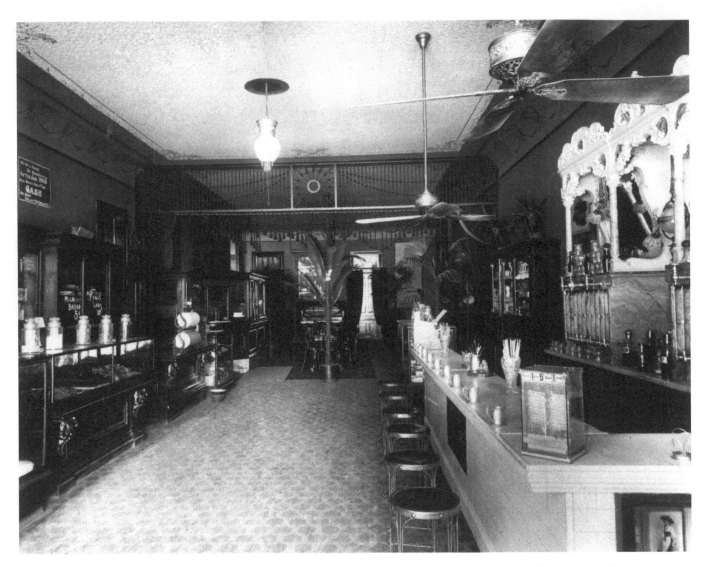

Henry Sudekum's ice cream business, located at 817 Broadway. Years later, Sudekum's would eventually become Sealtest ice cream.

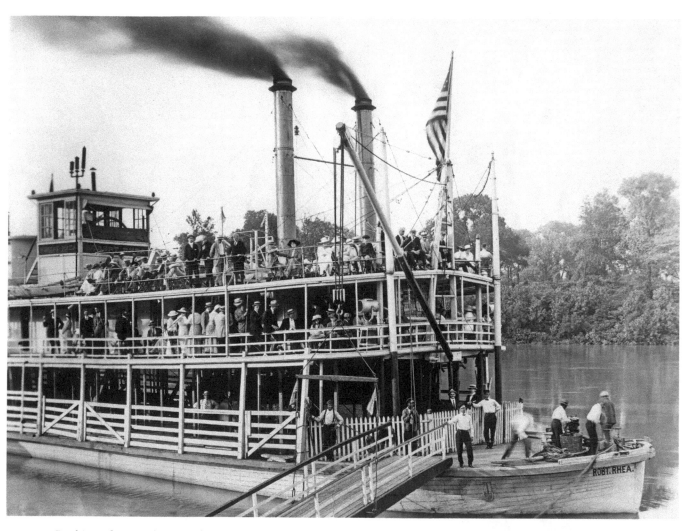

Banking of a steamboat on the Cumberland in 1915. Steamboats unloaded their passengers and goods to the backs of the buildings on First Avenue.

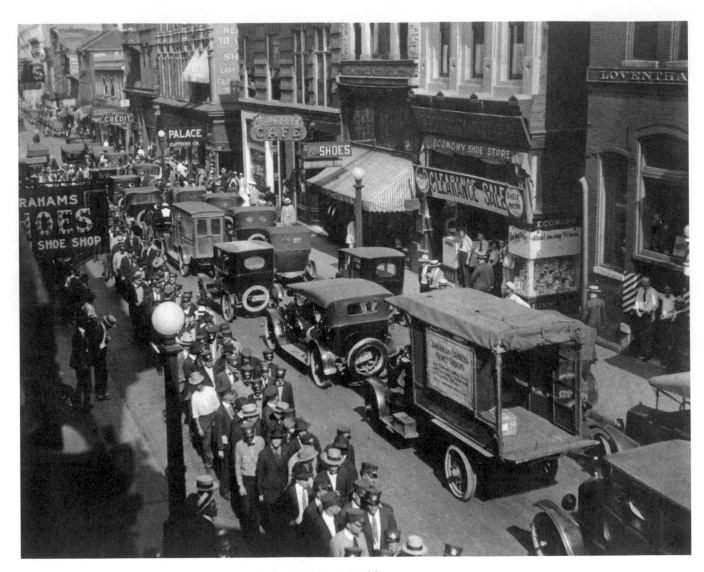

Union Street from Fifth Avenue during a parade for World War I soldiers.

The First World War and a Growing Metropolis

(1917–1939)

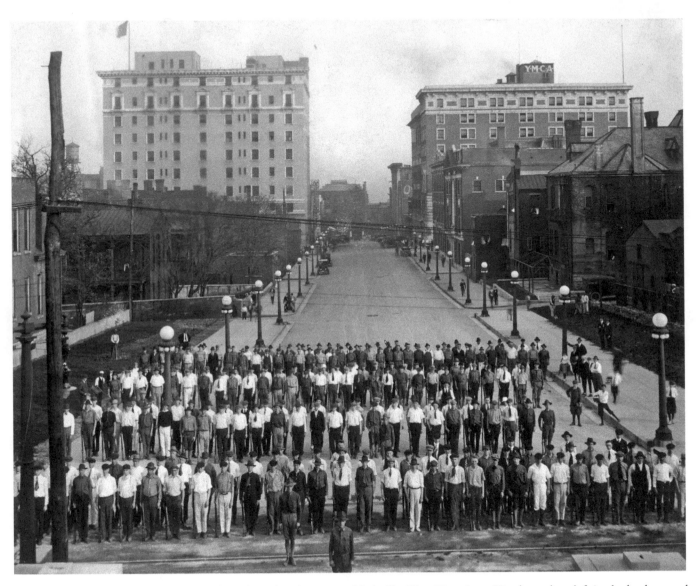

World War I Recruits line up on Capitol Boulevard in downtown Nashville. The Hermitage Hotel stands at left in the background.

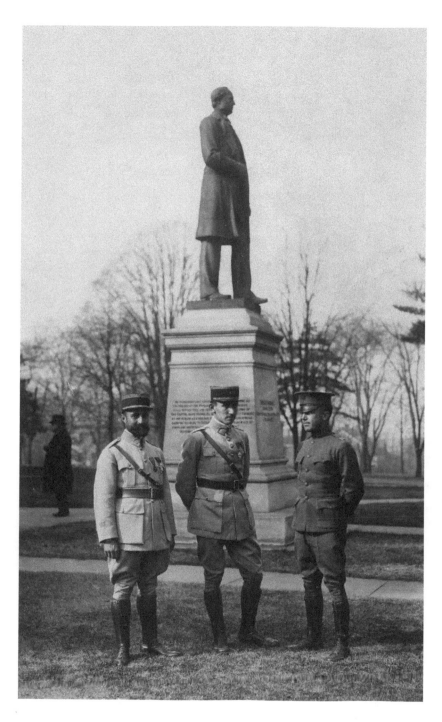

In November 1917, two French soldiers, Captain Loriot and Lieutenant Delaroche-Vernet, stand with a U.S. soldier, Captain Hobson, near the statue of Cornelius Vanderbilt in front of College Hall on the Vanderbilt campus. The Commodore's statue was paid for by Nashville citizens and the faculty of the university and displayed first at the Tennessee Centennial Exposition. The sculptor was Giuseppe Moretti.

The State Capitol, 1920.
Construction started in
1845 and was completed
in 1859. The building
was designed by William
Strickland, who died
during construction
and is buried in the
northeast wall on the
first floor.

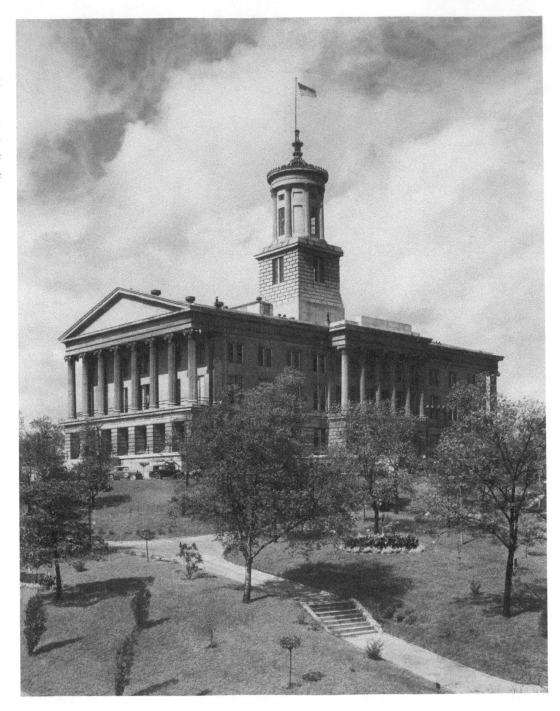

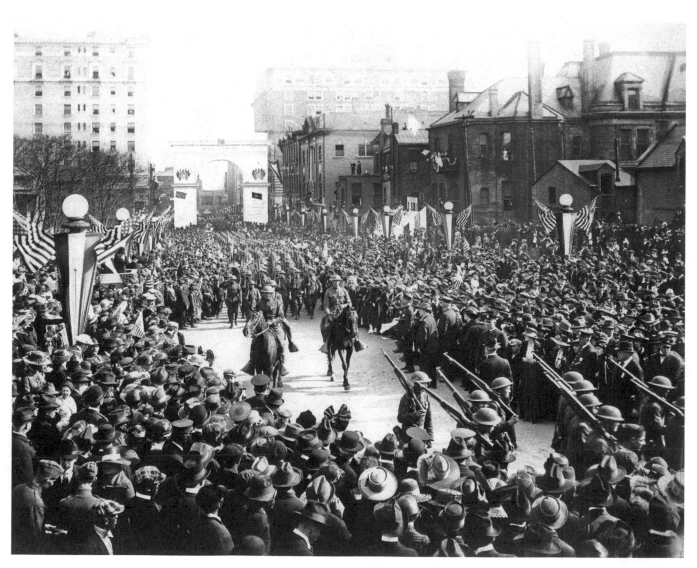

Crowds gather at the parade celebrating the return of soldiers at the end of World War I.

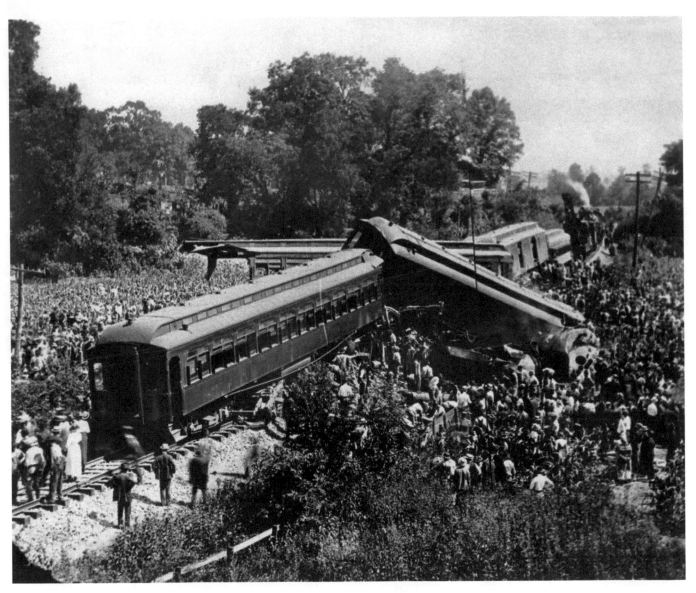

On July 9, 1918, a Nashville, Chattanooga & St. Louis Railroad train derailed at Dutchman's Bend, killing over 100 people and injuring more than 170. It was the worst train wreck in U.S. history. A greenway off White Bridge Road now gives hikers access to the site, where a sign describes the tragedy.

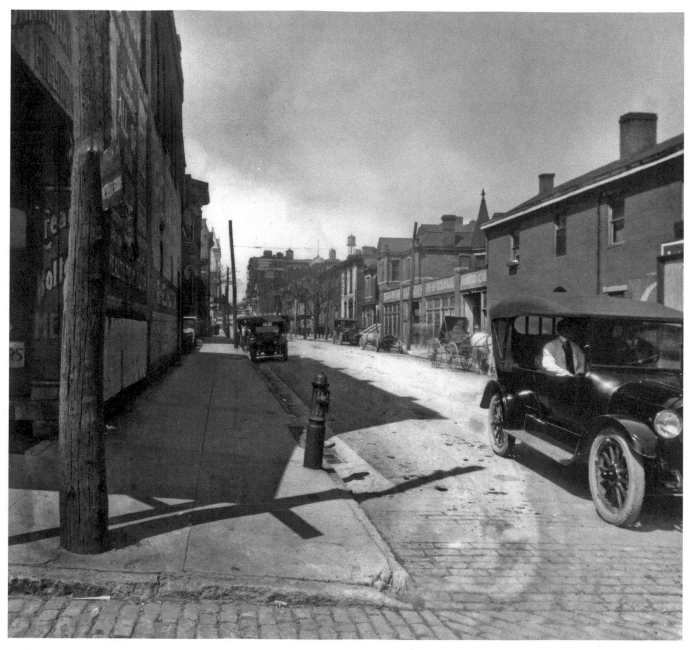

The transition from the horse and buggy to the automobile is illustrated in this view of Sixth Avenue from 1919. The R. D. Ezell Auto Company, at 106 Sixth Avenue North, is on the right side of the street.

The Frost Building, erected by the Southern Baptist Sunday School Board on Eighth Avenue in 1913, still serves Baptist publishing today. The building was named for Dr. J. M. Frost, Executive Secretary of the board.

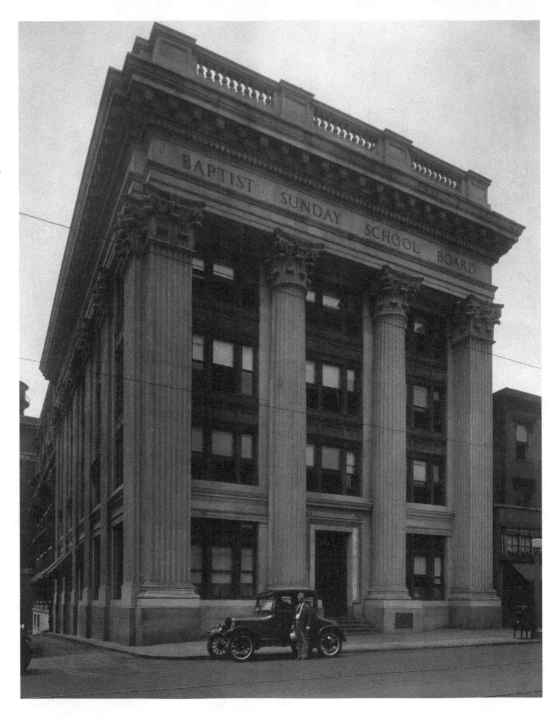

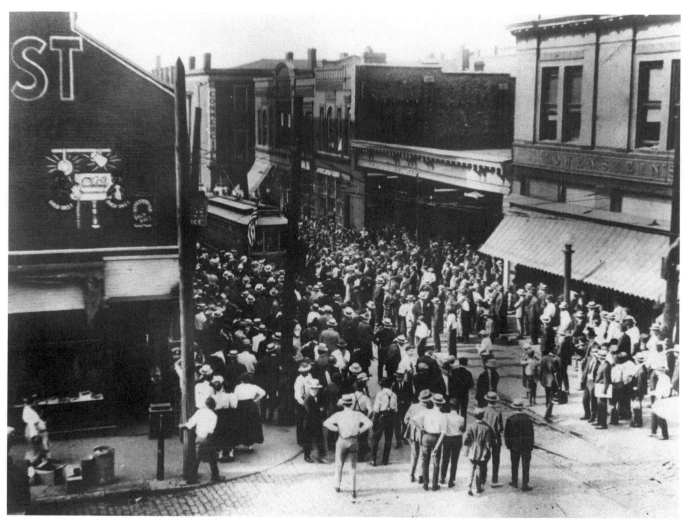

A crowd at Fourth and Deaderick streets at the streetcar transfer station. From this location people transferred from one car line to another, on this day to attend a baseball game at Sulphur Dell.

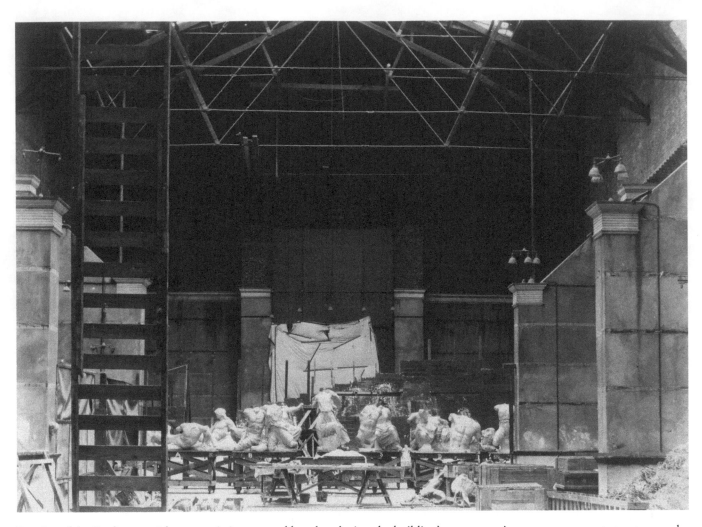

Interior of the Parthenon with statues sitting on workbenches during the building's reconstruction, as a permanent structure made of concrete, in the 1920s.

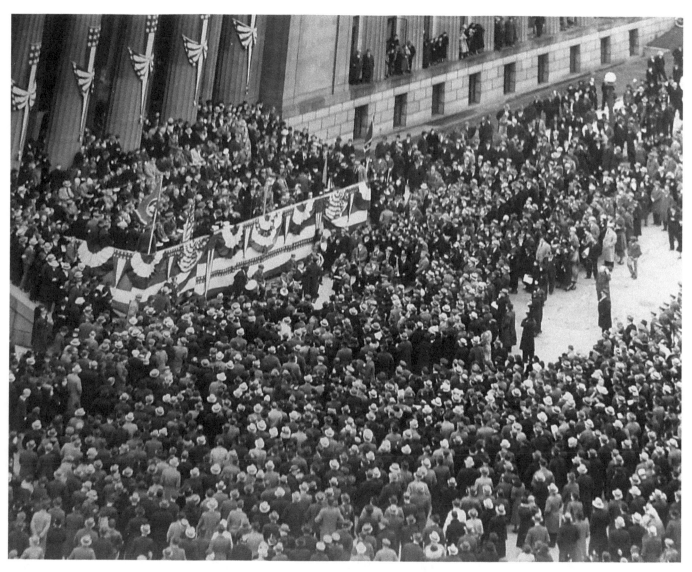

Crowds gather for the inauguration of Tennessee governor Hill McAlister at War Memorial Auditorium in 1933.

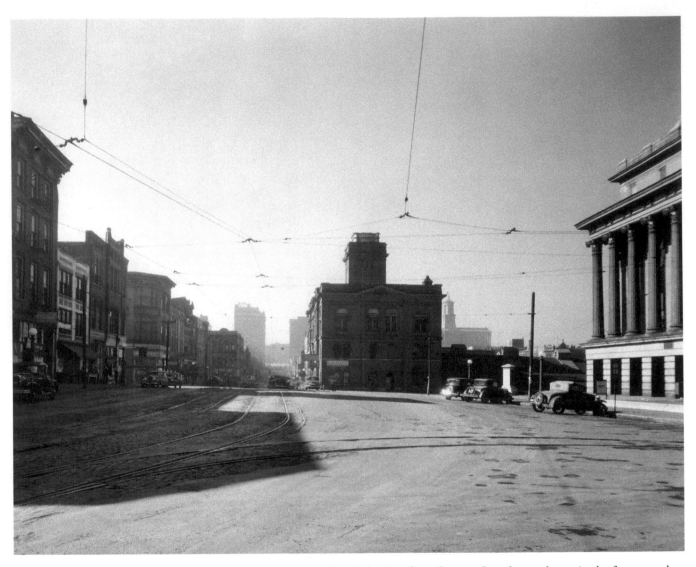

View of the Public Square in the late 1920s, with the City Hall and the Davidson County Courthouse shown in the foreground and the Andrew Jackson Hotel, the Cotton States Building, and the State Capitol visible in the distance.

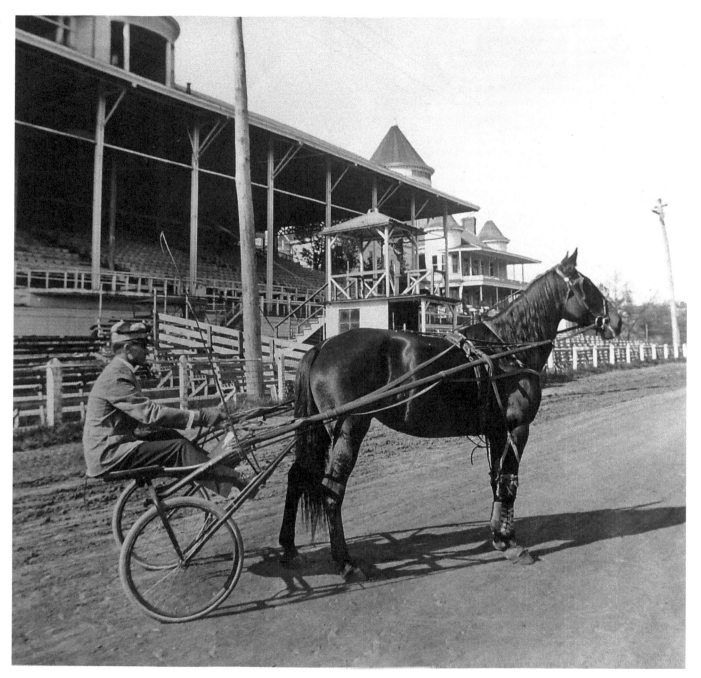

Harness racing was once popular at the State Fairgrounds.

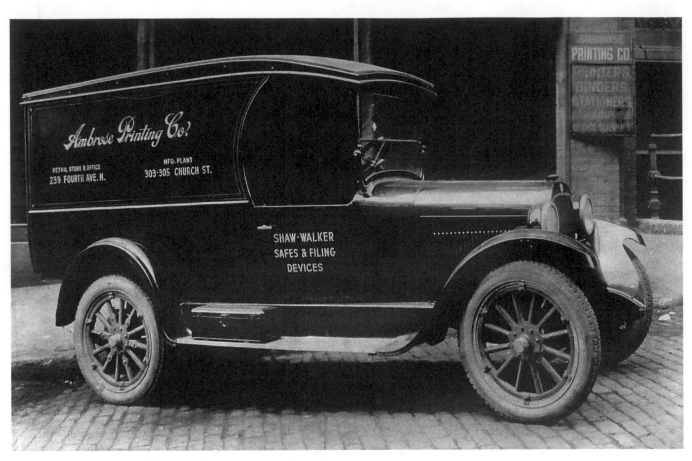

Ambrose Printing Company's Flat Panel Dodge Brothers' Delivery Truck, circa 1922-24. Ambrose was one of the original printers of Printers Alley, starting business in 1865. They were the last to vacate the alley, in 1976, and are now located in Metro Center.

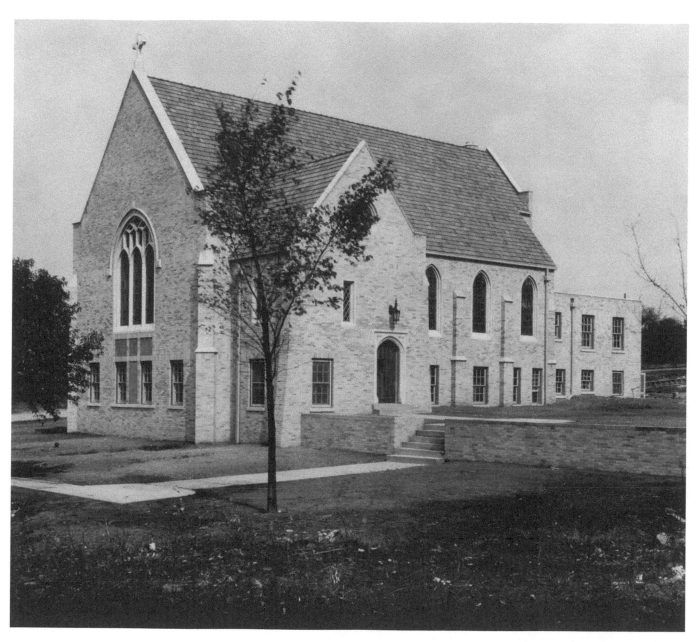

Woodmont Baptist Church, at the corner of Woodmont Boulevard and Hillsboro Road.

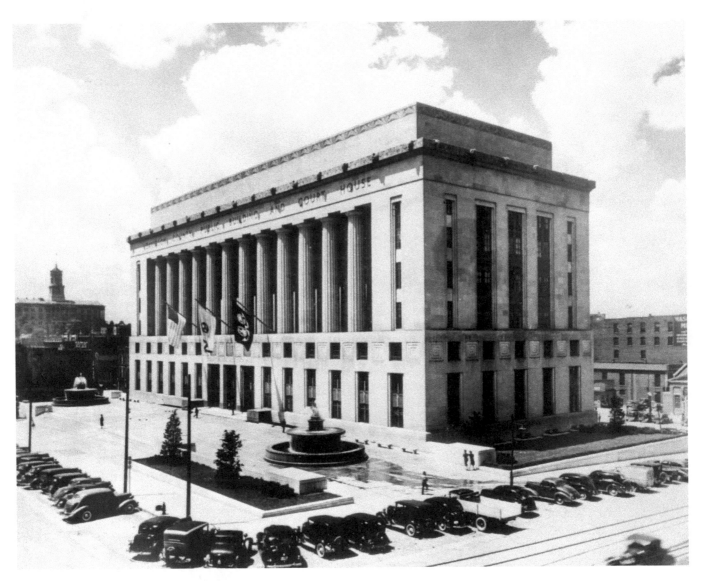

The Davidson County Courthouse, circa 1939.

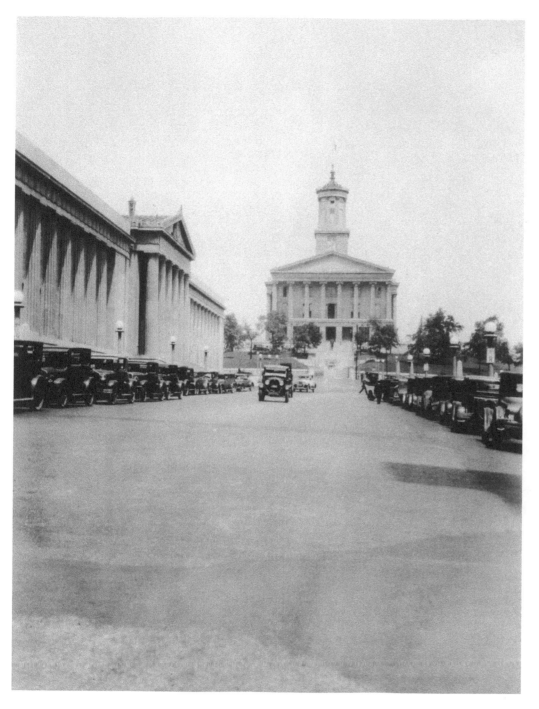

South facade of the State Capitol. The War Memorial Building stands on the left, built in 1925 in honor of the 3,400 Tennesseans lost in World War I.

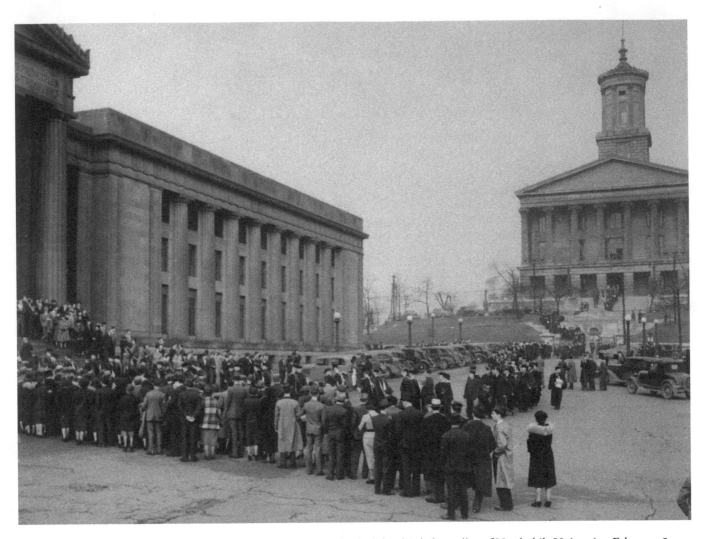

Academic procession for the inauguration of Oliver C. Carmichael as the third chancellor of Vanderbilt University, February 5, 1938, held in the War Memorial Auditorium.

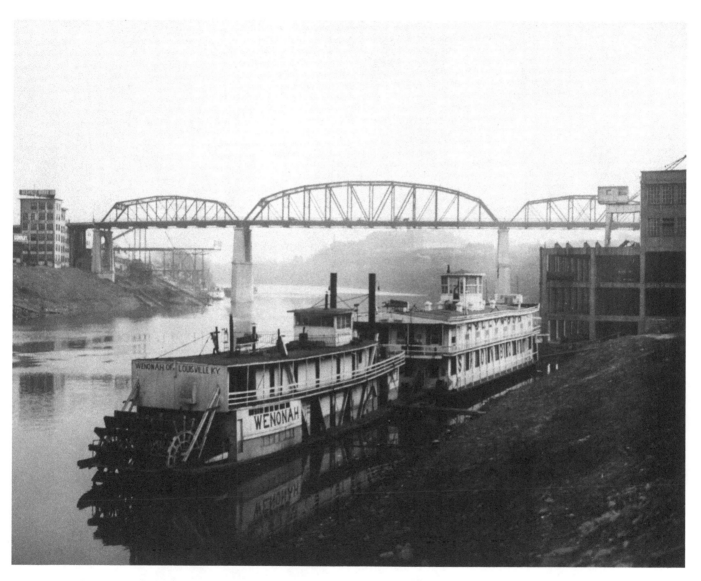

Steamboats *Wenonah* and *Hollywood* are moored on the Cumberland River at the Nashville riverfront. Items were unloaded from the paddlewheel boats to the rear of the buildings on First Avenue, and merchants sold the goods through the fronts of their buildings on Second Avenue. The Nashville Bridge Company's six-story building rises across the river beside the Shelby Street Bridge.

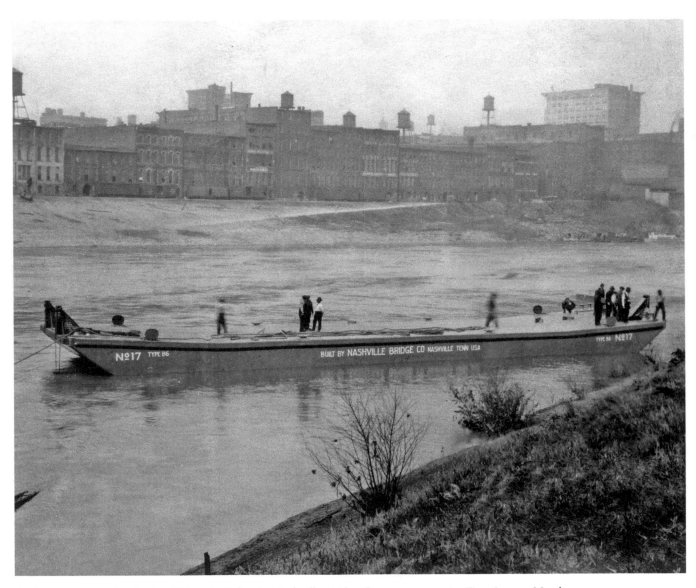

Steel barge on the Cumberland River, built by the Nashville Bridge Company, opposite First Avenue North.

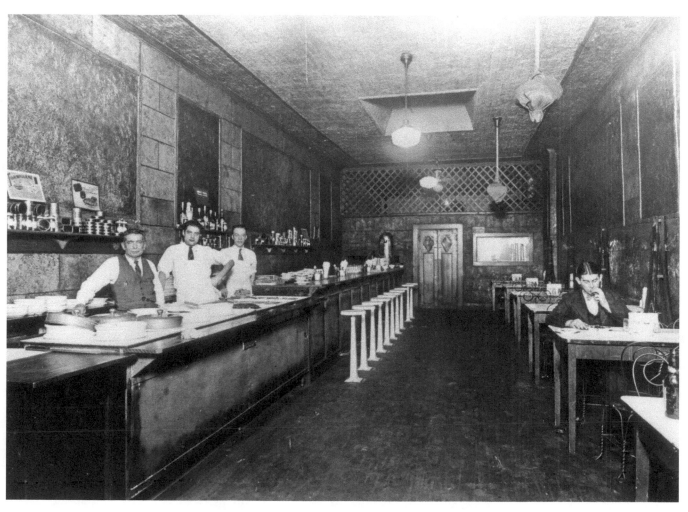

Frank Varallo poses for the camera inside his Chili Parlor, located at 811 Church Street, around 1930.

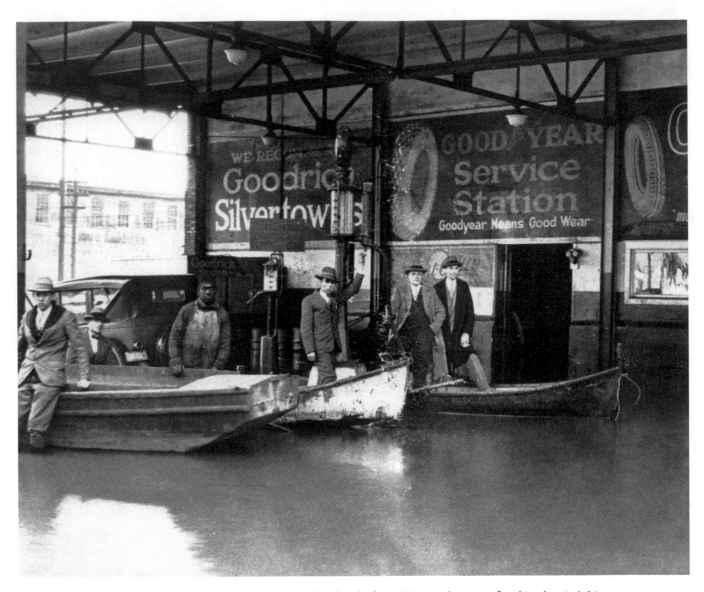

Merchants trade automobiles for boats during the December flood of 1926. It was the worst flood in the city's history up to that time.

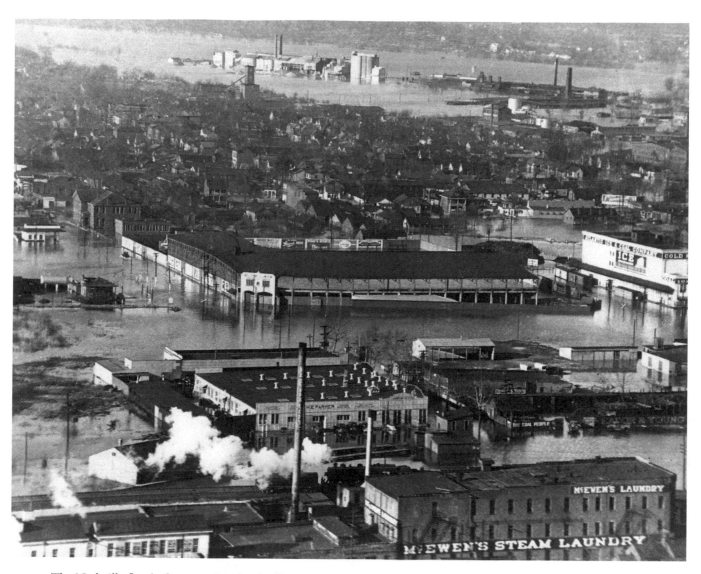

The Nashville flood of 1937. After this flood, the Tennessee Corps of Engineers dammed the Cumberland River to prevent future flooding.

James Caldwell, one of
Nashville's wealthiest
businessmen.

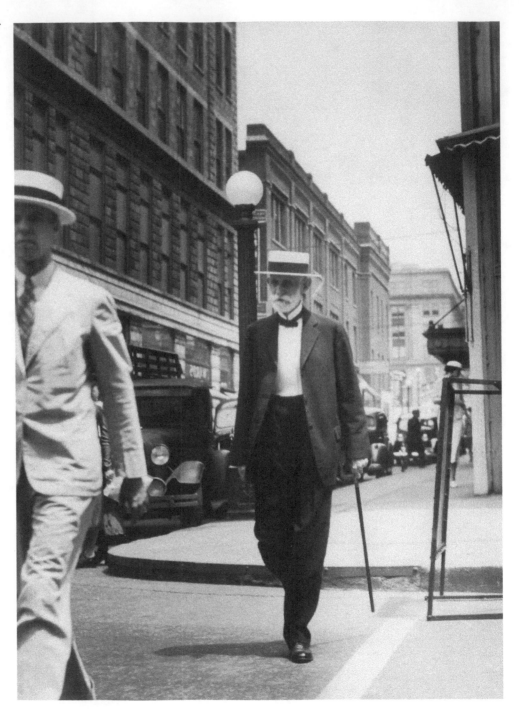

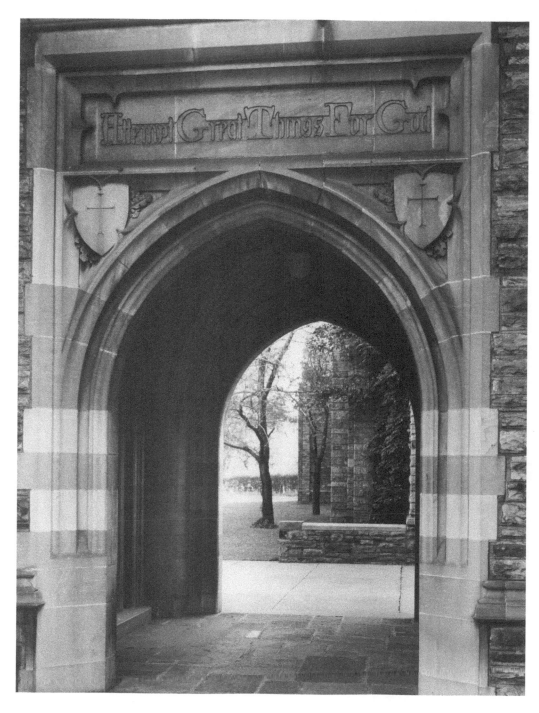

Established by the Methodist Church as an institution to train women wishing to become missionaries, Scarritt College relocated to Nashville from Kansas City in 1924. The Nashville campus was located on 19th Avenue South and was for a time affiliated with Peabody College.

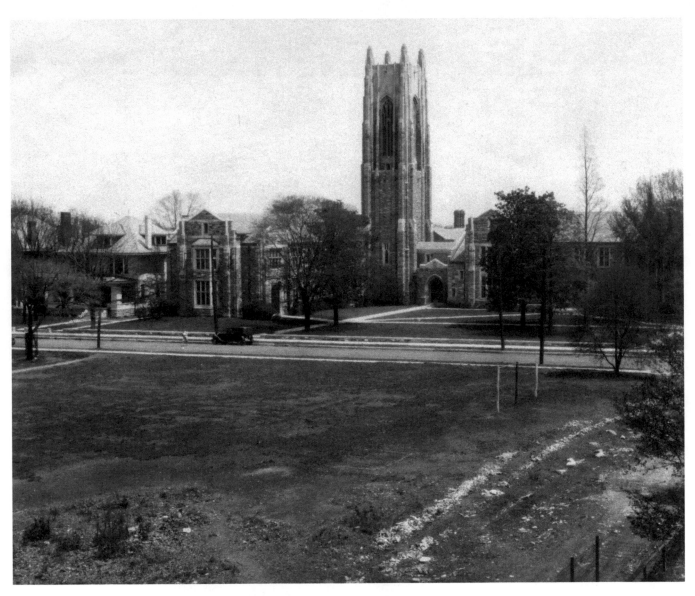

The Scarritt College Tower, designed by Henry C. Hibbs of Nashville, was completed in 1928.

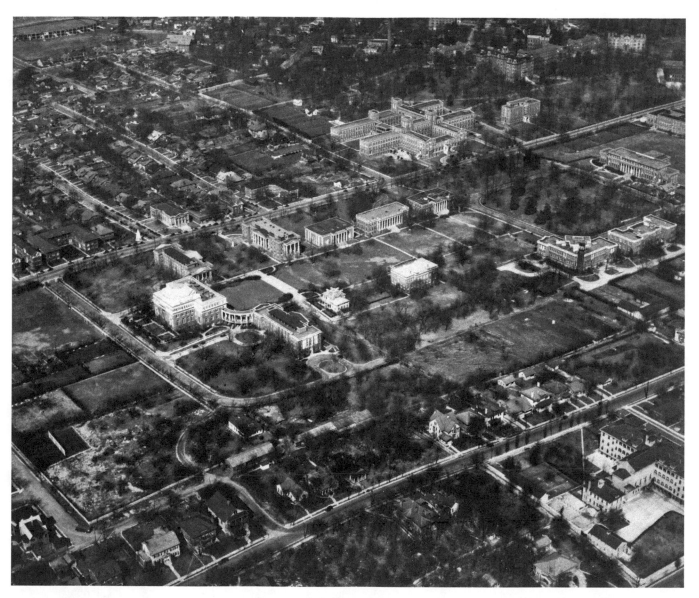

Aerial view of George Peabody College, late 1920s to early 1930s. Peabody College merged with Vanderbilt University in 1979.

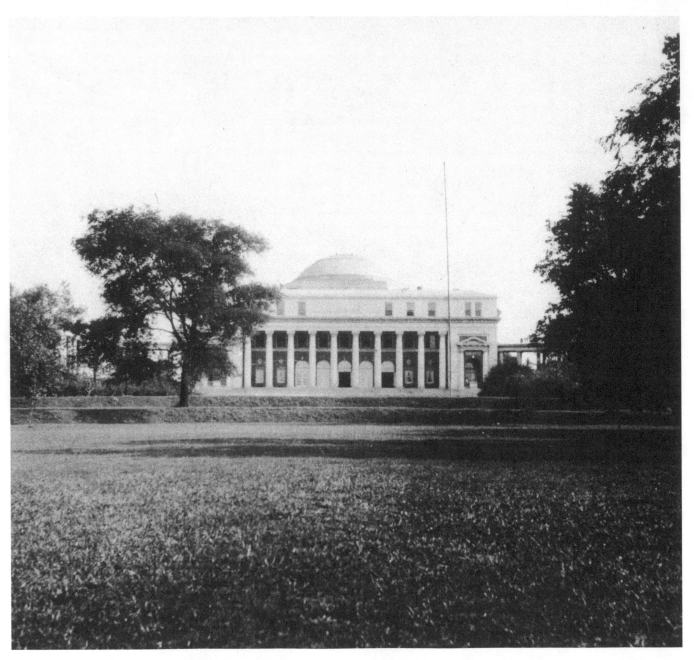

The Social Religious Building located on George Peabody Campus. Built in 1915, it was renamed the Faye and Joe Wyatt Center for Education on April 29, 2000.

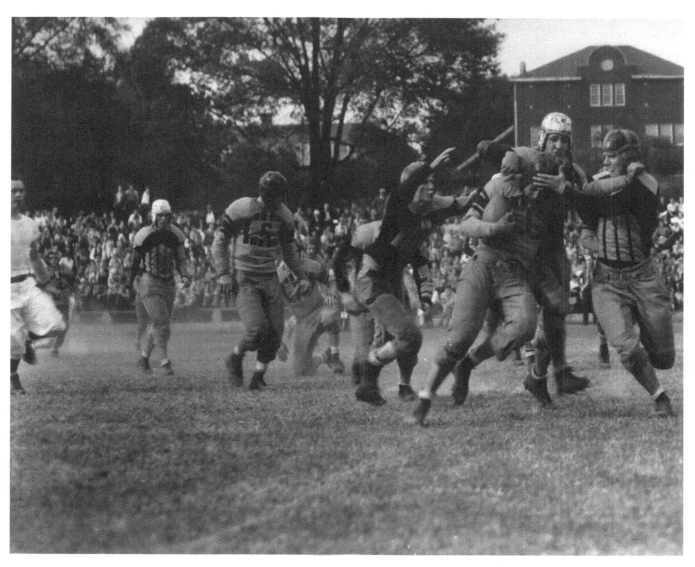

Nashville Central High football team is in action in the 1930s.

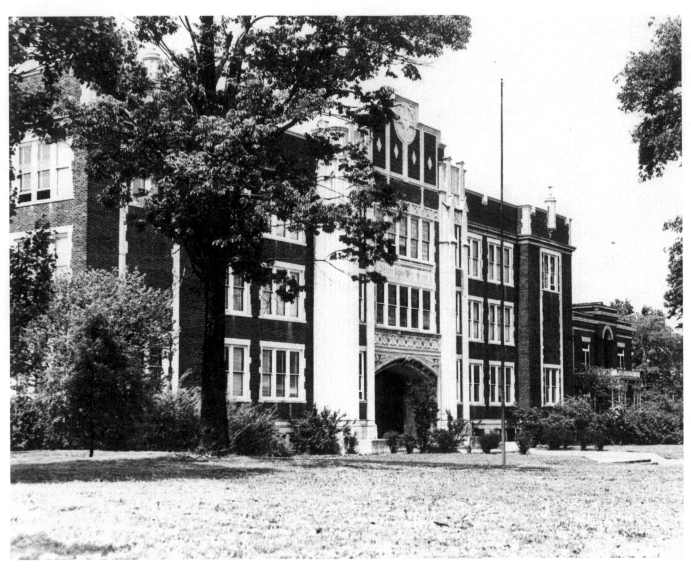

Father Ryan High School's Elliston Place campus was dedicated in 1929. The school relocated to a larger campus in the 1990s.

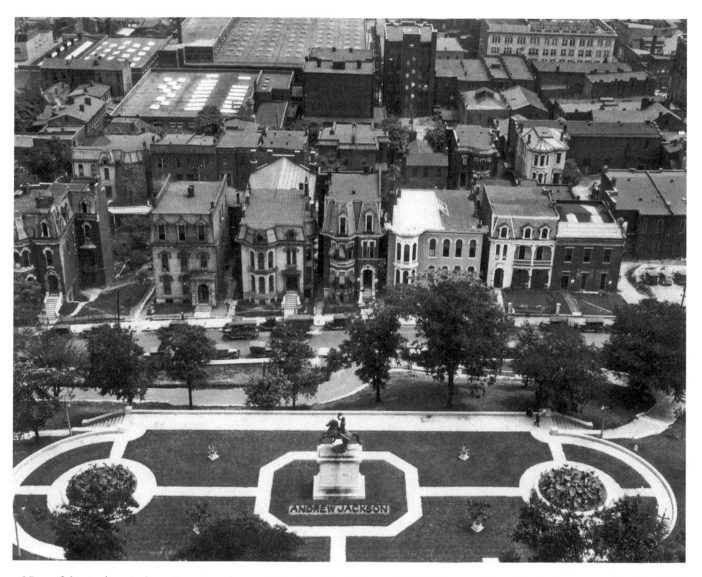

View of the Andrew Jackson Statue on the east side of the Capitol grounds. This is one of three identical statues created by Clark Mills. A second is in Washington, D.C., and the third is in New Orleans, Louisiana.

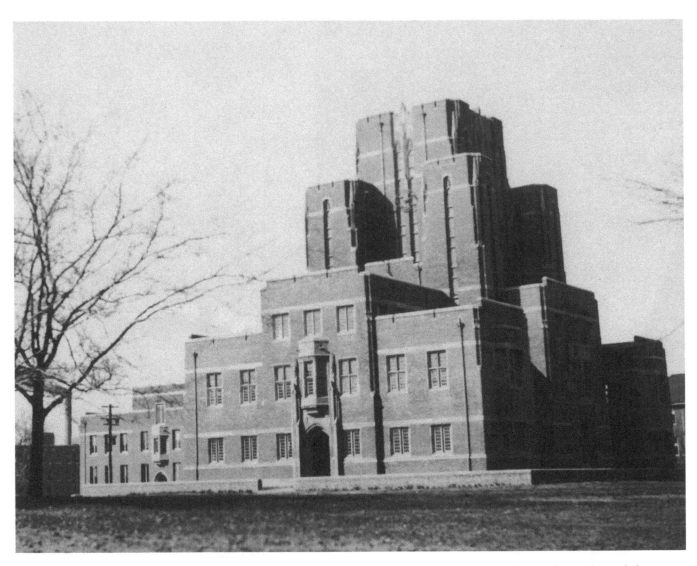

Fisk University Library, circa 1931. Fisk began classes in 1866 within former Union Army barracks, which were located close to the Union Station Hotel.

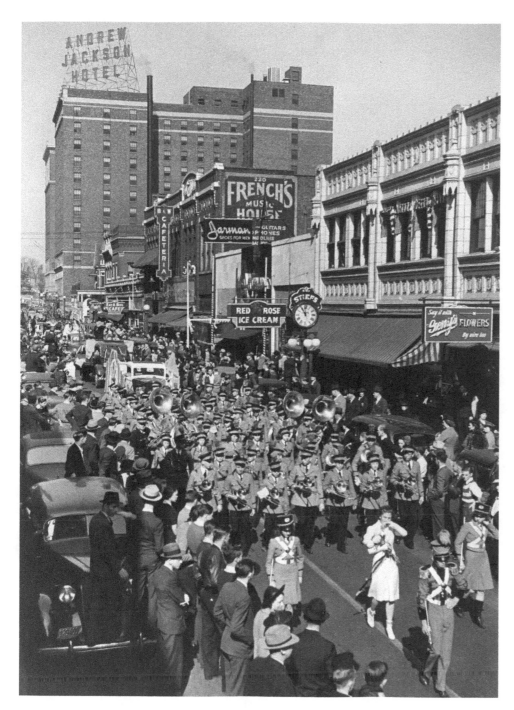

A parade on Sixth Avenue, celebrating a Vanderbilt Homecoming in the 1940s. The 1940 team was the first year of head coach Red Sanders. His coaching career was interrupted during World War II, when he became a lieutenant commander in the Navy. In 1996, he was elected to the College Football Hall of Fame for his coaching.

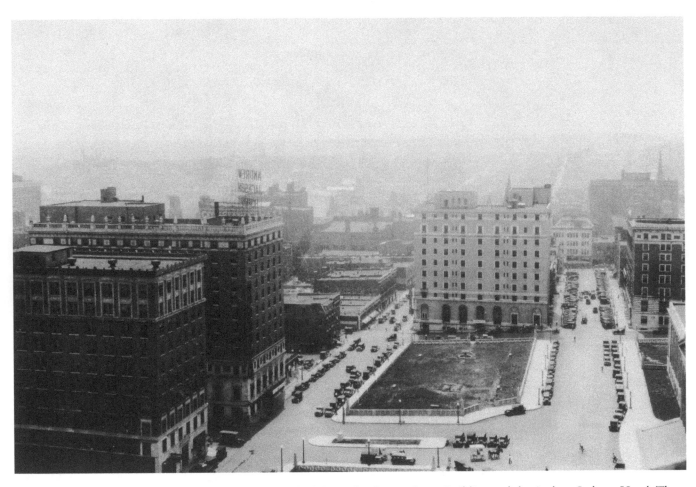

Memorial Square from Capitol Hill. The buildings to the left are the Cotton States Building and the Andrew Jackson Hotel. The Hermitage Hotel faces the State Capitol.

EMERGENCE OF THE MODERN CITY

(1940–1979)

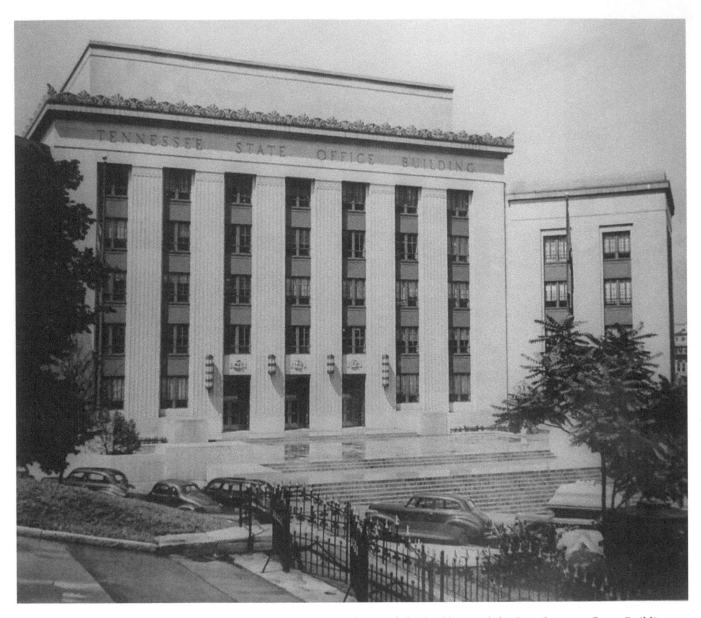

Tennessee State Office Building shortly after its completion in 1940. Until this building and the State Supreme Court Building (1937) were erected, the entire state government was housed in the Tennessee State Capitol and its annex.

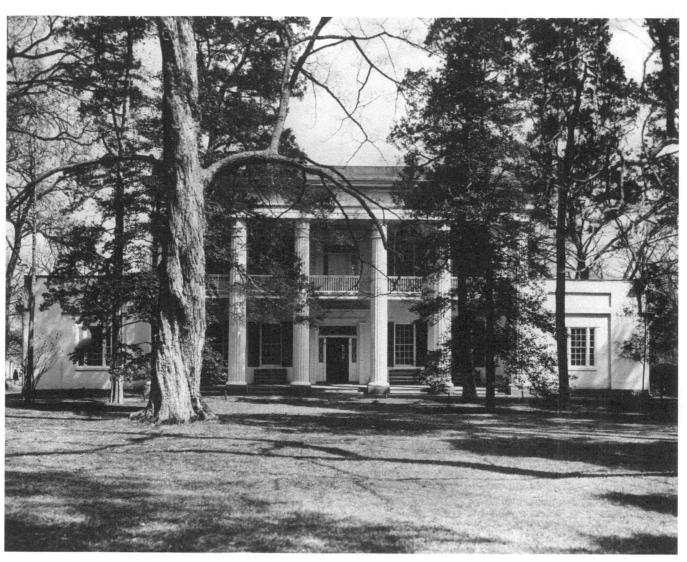

View of Andrew Jackson's home, the Hermitage, in 1941. The Jacksons moved to the Greek Revival–style home in 1821.

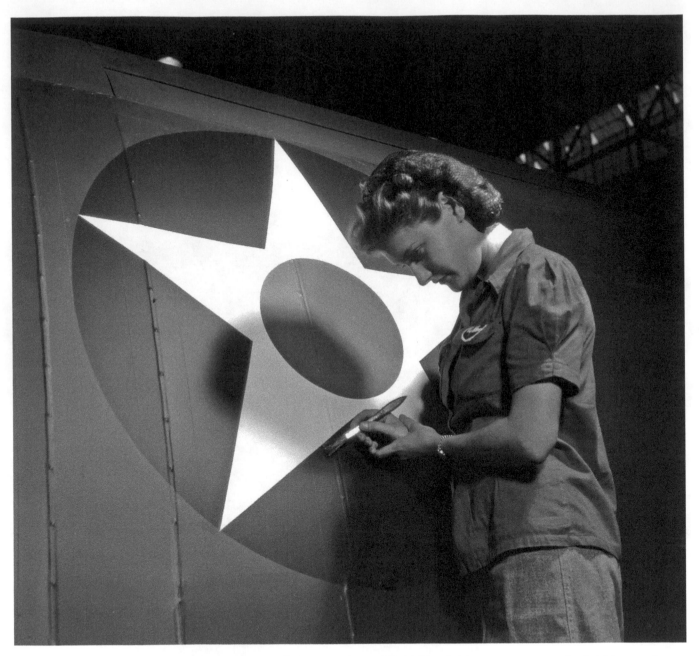

Rosie the Riveter played a key role working in Nashville factories during World War II. Here a woman puts the finishing touches on a military insigne on the fuselage of a Vengeance dive-bomber at the Vultee factory in Nashville.

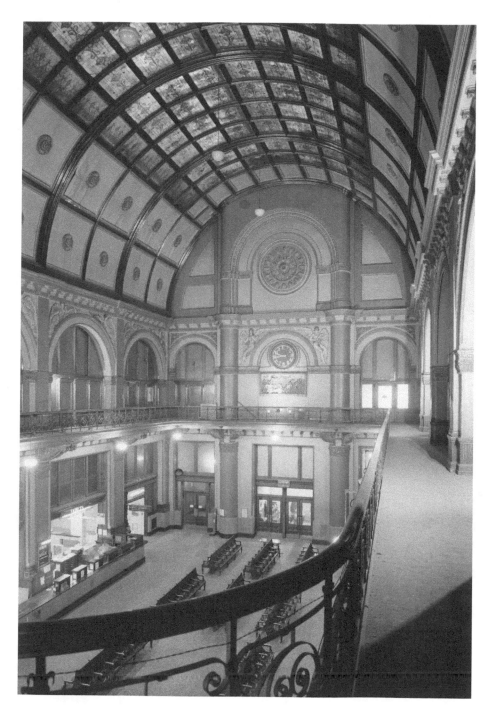

The interior of Union Station in the 1940s. Union Station stayed in business until the early 1970s. It sat vacant until it was converted into a hotel in the 1980s.

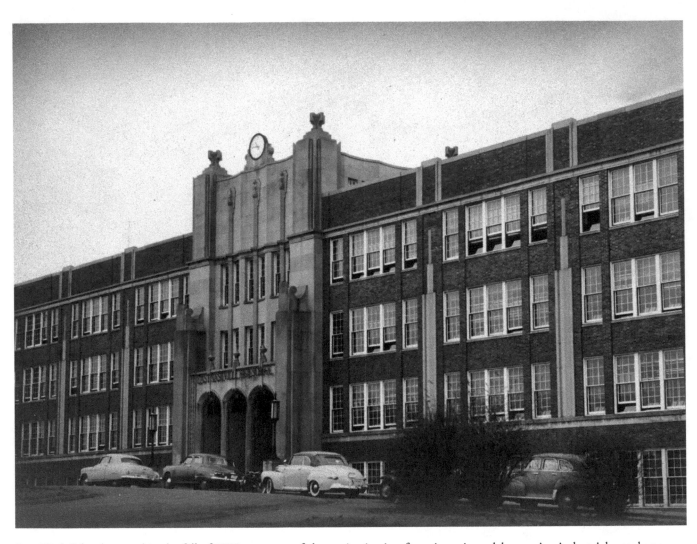

East High School opened in the fall of 1932 as a state-of-the-art institution featuring science laboratories, industrial arts shops, home economics, music, and art facilities.

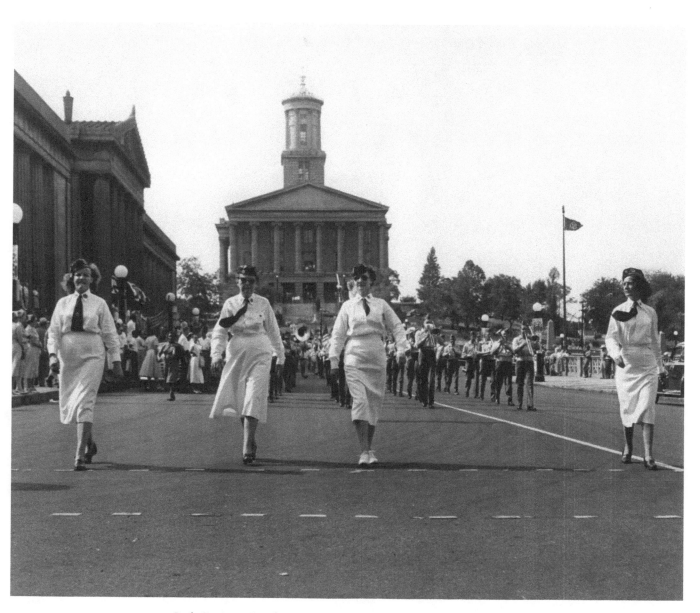

Lady Legionnaires from American Legion Post 5 march down Capitol Boulevard in a 1945 parade.

The rear of the Governor's Mansion was named "Far Hills" by its original owners, Mr. and Mrs. Ridley Wills.

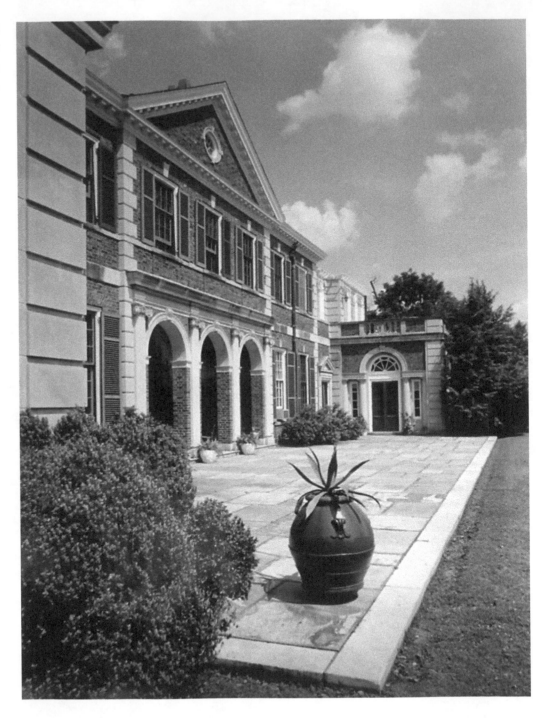

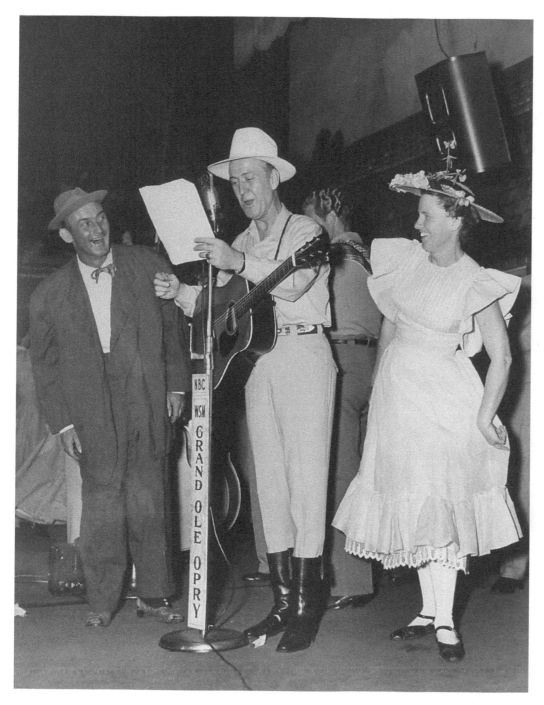

The WSM's *Grand Ole Opry* radio show in the 1950s. Pictured are Rod Brasfield, Red Foley, and Minnie Pearl. Roy Acuff is standing behind Red Foley.

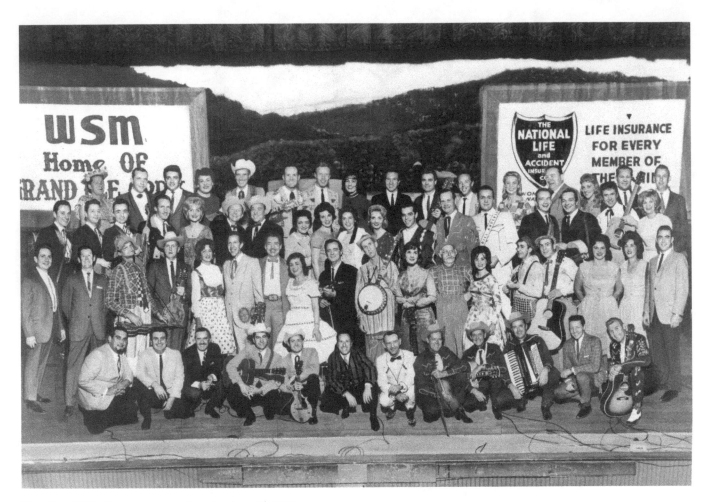

The Grand Ole Opry cast poses here in the mid 1960s.

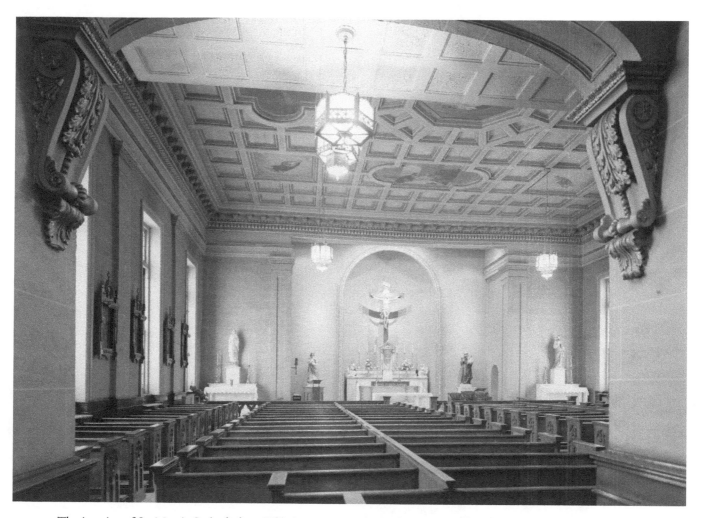

The interior of St. Mary's Cathedral on Fifth Avenue, circa 1960. Construction began in 1844 on the designs of Adolphus Heiman, Nashville's premier engineer-architect of that time.

Home of the Grand Ole Opry, the
Ryman Auditorium, circa 1969.

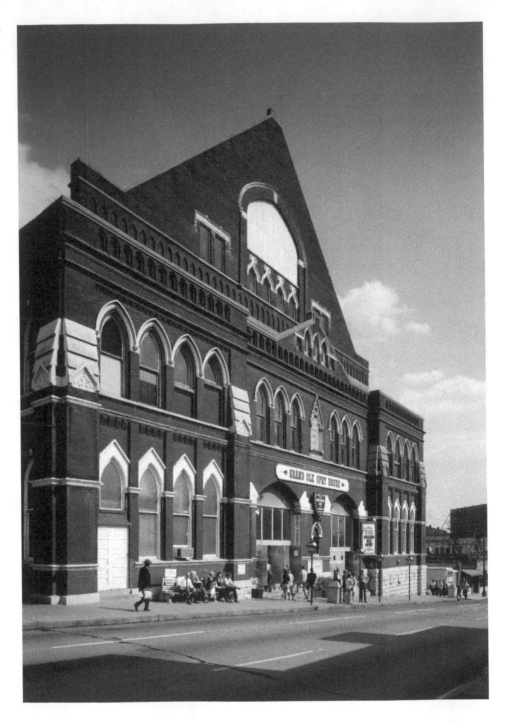

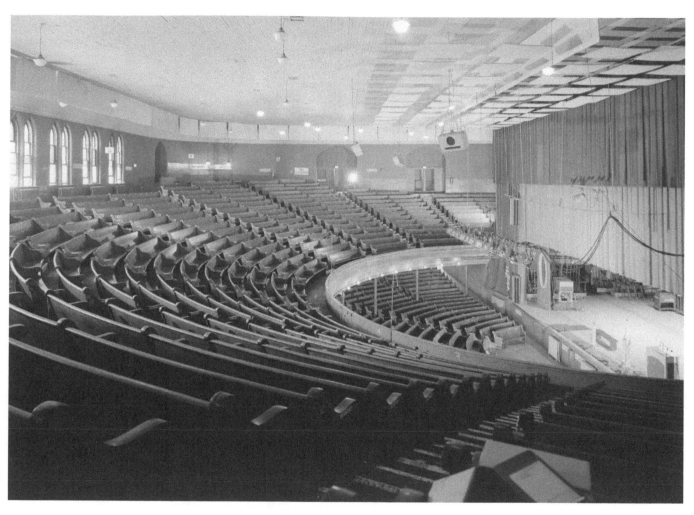

The Ryman Auditorium from the Confederate Gallery, constructed for the Reunion of Confederate Veterans held in June 1897.

Printer's Alley in the mid-1970s, showing the Embers nightclub and the Black Poodle.

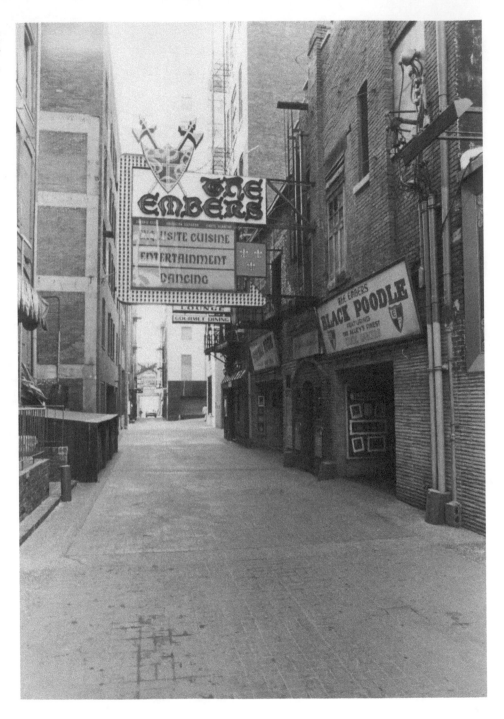

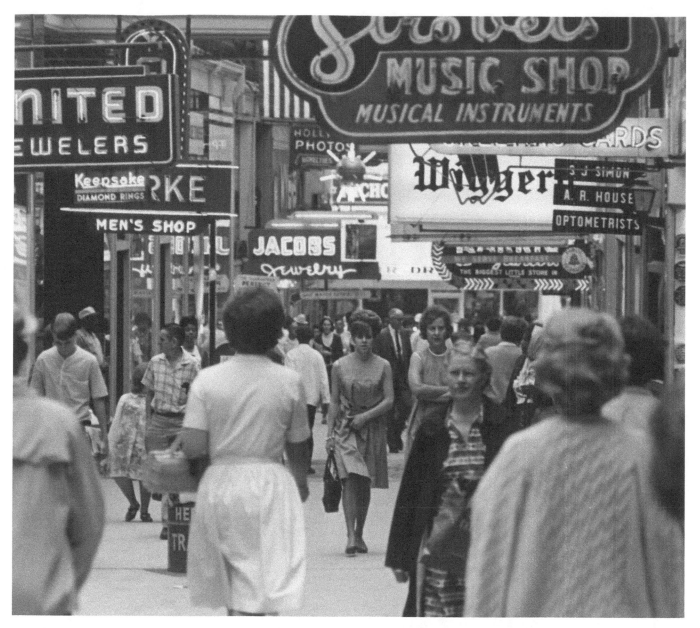

A crowd enjoys the downtown Arcade in the 1970s. Originally opened May 20, 1903, it was designed and built by Daniel C. Buntin. The Arcade also housed a pool hall that legendary pool hustler Minnesota Fats once called home. Fats was the model for the character Paul Newman played in the movie *The Hustler*.

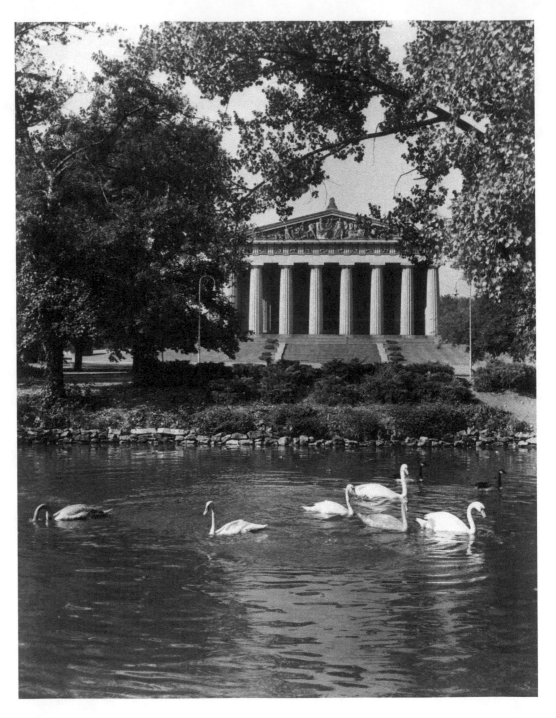

The Parthenon overlooks
Watauga Lake at
Centennial Park.

NOTES ON THE PHOTOGRAPHS

These notes, listed by page number, attempt to include all aspects known of the photographs. Each of the photographs is identified by the page number, photograph's title or description, photographer and collection, archive, and call or box number when applicable. Although every attempt was made to collect all data, in some cases complete data may have been unavailable due to the age and condition of some of the photographs and records.

II **UNION STATION DEPOT**
Michael A. Kaschak Collection
Vanderbilt University Special Collections and University Archives
sc.mss.0558.28

VI **PARTHENON WITH SHADOWS**
Vanderbilt University Special Collections and University Archives
pa.nas.part.15

x **NASHVILLE TOWN SQUARE, 1856**
Vanderbilt University Special Collections and University Archives
pa.nas.hist.1

2 **HYMES SCHOOL, 1857**
Farris Deep Collection
Tennessee State Library and Archives

3 **JOHNSON CONFECTIONERY**
Photo by T. F. Galtzman
Tennessee Historical Society
Tennessee State Library and Archives
Box 7, Folder 45

4 **LOG CABIN— JACKSON HOME**
Michael A. Kaschak Collection
Vanderbilt University Special Collections and University Archives
sc.mss.0588.09

5 **RAILROAD YARD**
Tennessee Historical Society
Tennessee State Library and Archives
Negative #6806

6 **RAILROAD BRIDGE OVER THE CUMBERLAND**
Photo by George N. Barnard
Library of Congress: Prints and Photo Division
LC-B811-2642

7 **CIVIL WAR ENCAMPMENT**
Tennessee State Library and Archives
DB3201

8 **FT. NEGLEY**
Photo by Lincoln Hichton
Tennessee State Library and Archives
DB1479

9 **FEDERAL OUTLINE**
Photo by George N. Barnard
Library of Congress: Prints and Photo Division
LC-B811-2639

10 **RAILROAD BRIDGE OVER THE CUMBERLAND**
Photo by George N. Barnard
Library of Congress: Prints and Photo Division
LC-B811-2642

11 **CAPITOL, 1863**
Photo by George N. Barnard
Library of Congress: Prints and Photo Division
LC-USZ63

12 **CUMBERLAND FORTIFIED BRIDGE**
Photo by George N. Barnard
Library of Congress: Prints and Photo Division
LC-B811-2641

13 **CAPITOL WITH COVERED GUNS**
Photo by George N. Barnard
Library of Congress: Prints and Photo Division
LC-B811-2629

14 **RAILROAD DEPOT**
Tennessee State Library and Archives
Drawer 17, Folder 185

15 **CIVIL WAR HOSPITAL**
Photo by George N. Barnard
Library of Congress: Prints and Photo Division
LC-B811-2634

16 **NASHVILLE VIEW 1864**
Photo by George N. Barnard
Library of Congress: Prints and Photo Division
LC-B811-2631

17 **VIEW FROM LINDSLEY HALL**
Photo by George N. Barnard
Library of Congress: Prints and Photo Division

VIEW OF THE CITY
Photo by George N. Barnard
Library of Congress: Prints and Photo Division
LC-B811-2633

18 **VINE STREET 1864**
Photo by George N. Barnard
Library of Congress: Prints and Photo Division
LC-B811-2635

19 **VIEW FROM CAPITOL**
Photo by George N. Barnard
Library of Congress: Prints and Photo Division
LC-B811-2627

20 **RAILROAD YARD**
Photo by George N. Barnard Library of Congress: Prints and Photo Division
LC-B811-2651

21 **CHURCH STREET TRAIN DEPOT**
Tennessee State Library and Archives
Drawer 17, File 186

22 **WHARF AND FRONT STREET**
Tennessee State Library and Archives
DB3777

23 **EAST SIDE OF PUBLIC SQUARE**
Photo by Calvert Photography

Tennessee Historical Society
Tennessee State Library and Archives
DB344

24 **VIEW OF UNION STREET**
Photo by Calvert Photography
Tennessee State Library and Archives
DB3700

25 **VANDERBILT UNIVERSITY**
Vanderbilt University Special Collections and University Library

26 **FIRST BAPTIST CHURCH**
Southern Baptist Historical Library and Archives

27 **NASHVILLE LIBRARY ASSOCIATION**
Photo by Calvert Photography
Tennessee State Library and Archives
DB3606

28 **RAILROAD BRIDGE— CUMBERLAND 1**
Tennessee Historical Society
Tennessee State Library and Archives
DB26593

29 **RAILROAD BRIDGE 2**
Tennessee Historical Society
Tennessee State Library and Archives
DB26594

30 **SUSPENSION BRIDGE**
Tennessee State Library and Archives
DB19612

31 **MARKET HOUSE, 1875-85**
Tennessee State Library and Archives

32 **CUMBERLAND RIVER**
Photo by Calvert Photography
Tennessee State Library and Archives
DB 1133

33 **HOLY TRINITY CHURCH**
Vanderbilt University Special Collections and University Archives
Holy_trinity

34 **NASHVILLE RAILROAD YARD**
Tennessee Historical Society
Tennessee State Library and Archives
Box 18 File 23

35 **ADDISON AVENUE**
Library of Congress: Prints and Photo Division
Lot 11299

36 **CITY HALL, 1890**
Vanderbilt University Special Collections and University Archives
pa.Nas.couh.1

37 **JACKSON'S TOMB**
Vanderbilt University Special Collections and University Archives
pa.nas.stat.5

38 **FOGG SCHOOL**
Photo by Calvert Photography
Tennessee State Library and Archives
DB27519

39 **NASHVILLE'S FIRST ELECTRIC STREETCAR**
Tennessee State Library and Archives
DB3543

40 **BOSCOBEL COLLEGE**
Photo by Calvert Photography
Tennessee State Library and Archives
DB 461

41 **DOUGLAS SANITARIUM**
Photo by Calvert Photography
Tennessee State Library and Archives
DB26156

42 **DOWNTOWN RESIDENTIAL STREET**
Tennessee State Library and Archives
DB3698

43 **HIGH STREET**
Tennessee State Library and Archives
DB3635

44 **DR. BRIGGS INFIRMARY**
Artwork of Nashville – 1864
Tennessee State Library and Archives
DB3013

45 **FRONT STREET**
Tennessee State Library and Archives
DB3550

46 **ELM STREET METHODIST CHURCH**
Vanderbilt University Special Collections and Library Archives
Elm_St_Meth

47 **POLK'S TOMB**
Vanderbilt University Special Collections and University Archives
nas.nash.stat.6

48 **EAST SIDE OF MARKET SQUARE**
Photo by Calvert Photography
Tennessee State Library and Archives

49 **GENERAL VIEW OF CENTENNIAL CELEBRATION**
Tennessee State Library and Archives
DB4590

50 **GOVERNMENT BUILDING**
Tennessee State Library and Archives
DB4543

51 **GIANT SEESAW**
Tennessee State Library and Archives

52 **PARTHENON CENTENNIAL**
Vanderbilt University Special Collections and University Archives
pa.nas.part.2

53 **CARRIAGE DECORATED FOR CENTENNIAL EXPOSITION**
Photo by Calvert Photography
Tennessee State Library and Archives
DB4582

54 **NASHVILLE SILVER DOLLAR SALOON, 1900**
Tennessee State Library and Archives
DB 3514

56 **NASHVILLE BREWING CO.**
Tennessee State Library and Archives
DB 3920

57 **OLD CITY HALL**
Tennessee State Library and Archives

58 **A VIEW OF THE CUMBERLAND RIVER IN BACKGROUND OF NASHVILLE**
Tennessee State Library and Archives
DB 29053

59 **THE DUNCAN HOTEL**
Tennessee State Library and Archives

60 **BILL SIGNING**
Tennessee State Library and Archives

61 **UNION GOSPEL TABERNACLE**
Photo by Calvert Photography
Tennessee State Library and Archives
DB 3470

62 **UNION STREET, 1906** Tennessee State Library and Archives

63 **STREETCAR ON BUCHANAN STREET**
Tennessee State Library and Archives
DB 3650

64 **PORTERS, COOKS, AND SERVERS**
Vanderbilt University Special Collections and University Library
Pa.fas.staf.012

65 **DIVINITY SCHOOL**
Vanderbilt University Special Collections and University Archives

66 **CHERRY STREET LOOKING NORTH**
Tennessee State Library and Archives
DB 3518

67 **SEVENTH AND BROADWAY, 1910**
Tennessee Historical Society - Tennessee State Library and Archives
Box 10A File 21

68 **FIRST AVENUE FLOOD**
Tennessee State Library and Archives
DB 3551

69 **VINE STREET SYNAGOGUE**
Tennessee State Library and Archives
DB 27981

70 **FISK JUNIOR PREP CLASS, 1900**
Library of Congress: Prints and Photo Division
Lot 11299

71 **VIEW FROM VANDERBILT**
Vanderbilt University Special Collections and University Archives

72 **HERMITAGE CARRIAGE, 1909**
Minnie Elvie Sutcliff Collection
Vanderbilt University Special Collections and University Archives
sc.mss.0563.059

73 **DUNCAN SCHOOL**
Vanderbilt University Special Collections and University Archives

74 **STREETCAR TRACKS**
Special Collections of the Nashville Public Library
The Nashville Room

75 **NEWSBOY**
Lewis Wickes Hine Photography
Library of Congress Photo Archive
LC-DIC-NCLE-03712

76 **MESSAGE DELIVERY BOY**
Lewis Wickes Hine Photography
Library of Congress Photo Archive
LOT 7480

77 **RESERVOIR BREAK, 1912**
Andrew C. Dorris Collection
Tennessee State Library and Archives
Drawer 12 Folder 224

78 **HENRY SUDEKUM'S ICE CREAM PARLOR**
Tennessee State Library and Archives
DB 4483

79 **RIVERBOAT DOCKING**
Vanderbilt University Special Collections and University Archives
pa.nas.scen.1

80 **WWI RECRUITS, CAPITOL BOULEVARD**
Vanderbilt University Special Collections and University Archives
pa.ww1.1.

82 **PARADE FOR RETURNING WWI TROOPS**
Tennessee State Library and Archives
Negative No. 251 Drawer 19, Folder 15

83 **STATE CAPITOL**
Vanderbilt University Special Collections and University Archives
pa.nas.capt.1

84 **CROWD AT CENTENNIAL PARK**
Vanderbilt University Special Collections and University Archives
pa.ww1.37.tif

85 **WWI RETURNING HOME**
Tennessee State Library and Archives Tennessee Historical Society
Box 14

86 **TRAIN WRECK**
Nashville Public Library Special Collections Department
The Nashville Room

87 **SIXTH AVENUE**
Tennessee State Library and Archives
DB 3634

88 BAPTIST SUNDAY SCHOOL BOARD
Life Way

89 STATUES IN PARTHENON
Leopold Scholz Collection
Vanderbilt University Special Collections and University Archives
sc.mss.0562.41

90 STREETCAR TRANSFER STATION
Nashville Public Library
Special Collections Division
The Nashville Room

91 GOVERNOR McALISTER
Tennessee State Library and Archives

92 PUBLIC SQUARE
Tennessee State Library and Archives

93 FAIRGROUNDS
Tennessee State Library and Archives

94 AMBROSE PRINTING TRUCK
Tennessee State Library and Archives

95 WOODMONT BAPTIST CHURCH
Southern Baptist Historical Library and Archives

96 DAVIDSON COUNTY COURTHOUSE
Committee on Architecture Surveys
Library of Congress Photo Archive
LC-USZ62-134595

97 WAR MEMORIAL AND CAPITOL
Michael A. Kaschak Collection
Vanderbilt University Special Collections and University Archives
sc.mss.0558.27

98 CARMICHAEL INAUGURATION AT WAR MEMORIAL AUDITORIUM
Vanderbilt University Special Collections and University Archives
pa.nas.warm.2

99 STEAMBOATS
Michael A. Kaschak Collection
Vanderbilt University Special Collections and University Archives
sc.mss.0559.25

100 STEEL BARGE
Tennessee State Library and Archives
DB 202

101 FRANK VARALLO'S CHILI PARLOR
Tennessee State Library and Archives
DB 4946

102 1926 FLOOD 1
Nashville Public Library
Special Collections Division
The Nashville Room

103 1937 FLOOD
US Corps of Engineers
Tennessee State Library and Archives

104 JAMES CALDWELL
Robert Wallace Collections
Tennessee State Library and Archives
DB 641

105 SCARRITT COLLEGE ARCH
Vanderbilt University Special Collections and University Archives

106 SCARRITT COLLEGE
Michael A. Kaschak Collection
Vanderbilt University Special Collections and University Archives
sc.mss.0558.22

107 GEORGE PEABODY COLLEGE
Vanderbilt University Special Collections and University Archives

108 SOCIAL RELIGIOUS BUILDING
Michael A. Kaschak Collection
Vanderbilt University Special Collections and University Library
sc.mss.0558.35

109 CENTRAL HIGH FOOTBALL GAME
Robert Wallace Collection
Tennessee State library and Archives
DB 3048

110 FATHER RYAN HIGH SCHOOL
Vanderbilt University Special Collections and University Archives

111 JACKSON STATUE
Vanderbilt University Special Collections and University Archives

112 FISK UNIVERSITY LIBRARY
Michael A. Kaschak Collection
Vanderbilt University Special Collections and University Archives
sc.mss.0558.05

113 HOMECOMING PARADE
Vanderbilt University Special Collections and University Archives
pa.uac.home.12

114 MEMORIAL SQUARE, 1940
Michael A. Kaschak Collection
Vanderbilt University Special Collections and University Archives
sc.mss.0558.12

116 STATE OFFICE BUILDING
Tennessee State Library and Archives

117 HERMITAGE, 1941
Tennessee State Library and Archives

118 VENGEANCE DIVE-BOMBER
Photo by Alfred T. Palmer
Library of Congress: Prints and Photo Division
LC-USW36-143

119 INTERIOR OF UNION STATION
Photo by Jack E. Boucher
Historic American Building Survey
Library of Congress: Prints and Photo Division
HABS, TENN 19, NASH 19

120 EAST HIGH SCHOOL
Vanderbilt University Special Collections and University Archives

121 LADY LEGIONNAIRES
Tennessee State Library and Archives

122 GOVERNOR'S MANSION
Tennessee State Library and Archives

123 GRAND OLE OPRY RADIO
Tennessee State Library and Archives

124 GRAND OLE OPRY CAST
Tennessee State Library and Archives

125 **ST. MARY'S CATHEDRAL**
Photo by Jack E. Boucher
Historic American Building Survey
Library of Congress: Prints and Photo Division
HABS, TENN 19, NASH 8

126 **GRAND OLE OPRY HOUSE**
Photo by Jack E. Boucher
Historic American Building Survey
Library of Congress Photo Archive

127 **CONFEDERATE GALLERY**
Photo by Jack E. Boucher
Historic American Building Survey
Library of Congress Photo Archive

128 **PRINTER'S ALLEY**
Vanderbilt University Special Collections and University Archives

129 **ARCADE**
Vanderbilt University Special Collections and University Archives
pa.nas.arca.3

130 **PARTHENON SWANS**
Vanderbilt University Special Collections and University Archives
pa.nas.part.5

Printed in the USA
CPSIA information can be obtained
at www.ICGtesting.com
JSHW072025140824
68134JS00042B/3787